ESRI Press

REDLANDS, CALIFORNIA

Children Map the World

Children Map the World

Selections from the Barbara Petchenik Children's World Map Competition

Jacqueline M. Anderson, Jeet Atwal, Patrick Wiegand, and Alberta Auringer Wood, editors

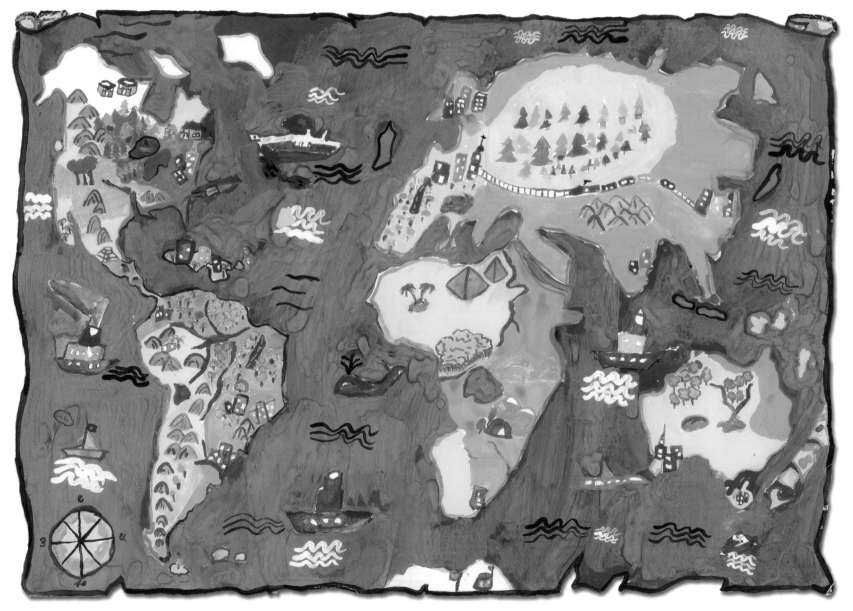

ESRI Press
REDLANDS, CALIFORNIA

Library of Congress Cataloging-in-Publication Data
Barbara Petchenik Children's World Map Competition. Selections.
Children Map the World : selections from the Barbara Petchenik Children's World Map Competition / Jacqueline M. Anderson ... [et al.], editors.—1st ed.
 p. cm.
 ISBN 1-58948-125-9 (pbk. : alk. paper)
 1. Map drawing—Competitions—Juvenile literature. I. Anderson, Jacqueline Margaret. II. Title.
 GA130B23 2005
 912—dc22 2005007658

Ask for ESRI Press titles at your local bookstore or order by calling 1-800-447-9778. You can also shop online at www.esri.com/esripress. Outside the United States, contact your local ESRI distributor.

ESRI Press titles are distributed to the trade by the following:

In North America, South America, Asia, and Australia:
Independent Publishers Group (IPG)
Telephone (United States): 1-800-888-4741
Telephone (international): 312-337-0747
E-mail: frontdesk@ipgbook.com

In the United Kingdom, Europe, and the Middle East:
Transatlantic Publishers Group Ltd.
Telephone: 44 20 8849 8013
Fax: 44 20 8849 5556
E-mail: transatlantic.publishers@regusnet.com

Cover map:
The Map of the World
Nikola Zlatanov
Age 7
Bulgaria
Children's Art Center, Sofia
1999

Cover design by Savitri Brant
Book design and production by Savitri Brant
Copyediting by Tiffany Wilkerson
Print production by Cliff Crabbe

The editors and publisher would like to thank the young cartographers whose work appears in this book.

Young cartographers

Patrick Wiegand and Jacqueline M. Anderson

The Barbara Petchenik Children's World Map Competition was created by the International Cartographic Association (ICA) in 1993 as a memorial for Barbara Bartz Petchenik, a past vice president of the ICA (the first woman to hold this office) and a cartographer who worked throughout her life with maps related to children.

The aims of the competition are

- to promote children's creative representation of the world
- to enhance their cartographic awareness, and
- to make them more conscious of their environment.

The competition is for children up to the age of sixteen and is held every two years during an ICA cartographic conference or an ICA general assembly. Each ICA member nation must nominate a coordinator to run the competition in his or her own country, and a national committee selects up to five maps to forward to the ICA secretary general. Further details of the competition can be found on the ICA Web site *(www.icaci.org)*. To date, thousands of children from fifty-two countries have been involved. Maps submitted to the competition by member nations are archived at Carleton University, Ottawa, Canada, and make up what is perhaps the largest ever collection of world maps created by children *(collections. ic.gc.ca/children)*.

This book presents a retrospective selection of one hundred maps submitted over the first decade of the competition. It includes award-winning entries and runners-up as well as many personal favorites of the editors. It is a stimulating collection of children's work that liberally illustrates the aims of the competition.

The images are, preeminently, *creative representations* of the world. Imaginative and eye-catching, they owe as much to art and graphic design as to cartography. The children have used a variety of

media to create their images: maps have been drawn, painted, crayoned, sewn, and knitted. Some (for example, page 38) have been glued from scrap materials. One (page 104) has been painted on a rock! The children have also employed a variety of artistic styles, reflecting the pluralist visual environment in which they are growing up. Some images seem reminiscent of works by major twentieth century artists (there are, for example, echoes of Matisse in the map on page 22). Several themes in the artwork recur. The world is often shown as being "in our hands" (pages 53, 59, 78, 81, 93), and people from many lands are portrayed as holding hands in friendship (pages 14, 74). Although adults may consider these clichés, for children they represent early steps to understanding environmental responsibility and international cooperation.

Children working together collaboratively is also a frequent theme (see, for example, pages 11, 61, 62). Throughout their work there is abundant evidence of the freshness of the children's imaginations. The spherical Earth appears as a basketball (page 67), hot air balloon (page 49), flower (pages 19 and 28), and human eye (page 100). It orbits the sun as a planetary snail (page 60), takes shelter under an umbrella (page 36), balances precariously on the edge of a cliff (page 103), and is rescued in a lifebelt (page 102). It is transformed into whimsical shapes, such as a cube (page 85), a dove (pages 22 and 29), a tree (page 24), a pipe (page 105), a mushroom (page 43), and a butterfly (page 90).

The images are, of course, also maps. The young cartographers who made them have had to make decisions about what to include and its symbology. Many, for example, have used pictorial symbols. At first, children generally locate pictures of unique phenomena on the map face. Animals are a popular choice (pages 4, 20, 80) as well as features of the built environment such as the Eiffel Tower, the Statue of Liberty, and the pyramids (pages 8, 65, 84). Later in their development, children begin to understand that objects can be classified and that a single symbol can be used to represent all the objects in one class. Older children have experimented with point, line, and area symbols, and, because the symbols are less picture-like and more abstract, they now recognize the need for a legend in order to help a map user understand what the map shows.

Because their task is to make a map of the world, the children have had to consider, at some level, the issue of an appropriate map projection. The youngest children typically draw the world as seen from space (page 2). But more sophisticated representations of the spherical Earth require children to study a globe in order to appreciate that not all the land masses can be seen from a single viewpoint. The effect that different world maps have on the shape and area of land masses will not generally be understood in any depth by children until they are at the upper end of the competition age range, but even very young children can recognize that you cannot make a flat map of the world without stretching, squeezing, or snipping. The map task also demands that competitors decide where to center their world map. A map made in China (page 41) is more likely to have the Pacific Ocean in the middle, whereas a map made in Sweden (page 58) will probably be centered on the Atlantic.

The images also show children's *awareness of their environment*. Younger children's maps are frequently accompanied by comforting images of childhood, such as a teddy bear (page 23). Older children more often show images of poverty (page 89), pollution (page 32 and 105), warfare (page 49), and

environmental degradation (page 109). Together with their titles, many of the images are extremely powerful. The world is represented as having been darned with thread or patched (page 27). It is as vulnerable as a scoop of ice cream in the sun (page 10). Children have also learned to use symbolic imagery such as the panda (pages 37 and 46), dove (pages 9, 22, 29), and rainbow (page 65). They have drawn on the protest art of posters, placards (page 72), and urban murals (page 52). The images reveal that competitors have been made aware of the potential of maps to persuade and the power of maps to promote a cause. Their maps overwhelmingly express core values: sustainable development, international understanding, and respect for others; and children are learning how to publicize these messages cartographically. The messages embedded in the maps are sometimes complex, often culturally unfamiliar. Yet the maps are accessible to us all.

The images in this book are only a small sample of those available. It is our hope that you, as an interested individual, parent, or teacher, will actively use these maps with children. Ask them which they like best and why. Discuss what the maps show and how the information is presented. Explain that maps are made up of points, lines, and areas and that what these mean often has to be explained in a legend. Compare the children's maps with a globe and other commercially produced maps of the world. Notice how the shape and size of the land masses can change from one map to another because of the various systems used to turn the spherical surface of Earth into a flat world map. Talk about the iconography in the children's representations. Why, for example, does the dove symbolize peace and why is the panda associated with endangered species? Encourage children to make their own maps so that they confront some of these issues for themselves. By stimulating children's interest in the nature of maps and mapping in this way, you will be able to promote their graphic literacy.

Although the maps in this book show children's early experimentation with cartographic principles, they also reveal an agenda for education. There is much these children do not yet understand about maps and how maps work. And there is probably also much that their teachers and parents would like to learn. As the children of today are the visualizers of spatial data, the mapmakers, and map users of the future, there is a key role here for the International Cartographic Association and, in particular, its Commission for Cartography and Children.

The Commission aims, internationally, to do the following:
- promote the use and enjoyment of maps by children and young people
- increase understanding of children and young people's engagement with maps
- raise the standard of maps and atlases produced for children and young people

To achieve these aims, members of the commission pursue scientific research into the cartographic literacy of children. They also advance better design and realization of educational maps and atlases and promote the use of digital cartography and geographic information systems (GIS) in schools. Outcomes of research in this field are disseminated through the commission's Web site *(lazarus.elte.hu/ccc/ccc.htm)*.

Barbara Petchenik herself undertook some of the first systematic data collection on children's cartographic thinking, though the maps from the competition that bears her name provide evidence of a

less systematic kind. Nevertheless, in their imaginative content and vitality they attest to children and young people's enduring interest in maps and the excitement to be had from them. Through the maps, children have been able to express something of their wishes, hopes, and fears for their world.

Proceeds from the sale of this book will go into a fund, administered by the International Cartographic Association, to promote graphic literacy, in developing countries and disadvantaged learners.

Age 5–9

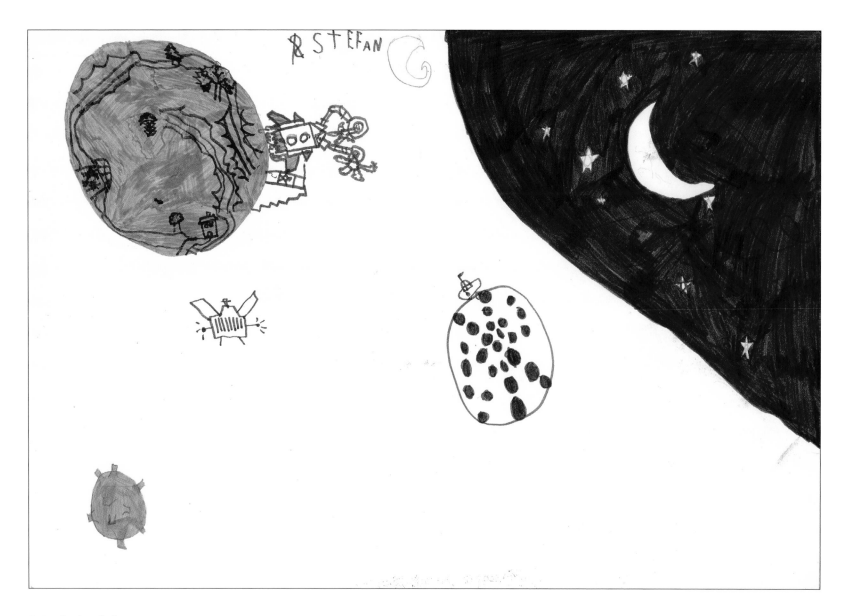

My World
Stefan Thompson Folch
Age 5
Chile
English Institute, Santiago
1995

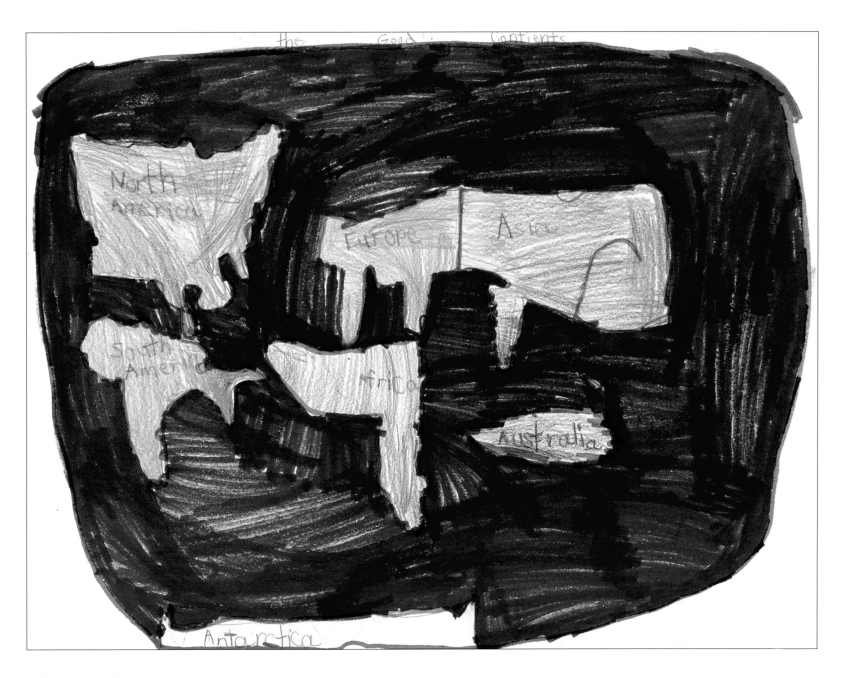

The Good Continents
Kristen Godwin
Age 6
United States
Washington Middle School, Cairo, Georgia
1995

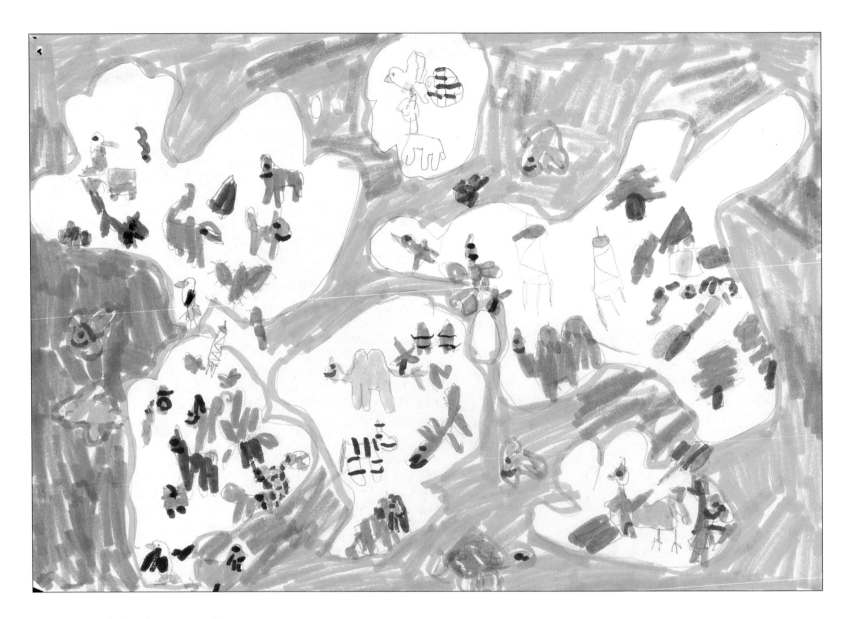

The World of Animals
Panagiota Tentzoglidi
Age 6
Greece
Kalamata
1999

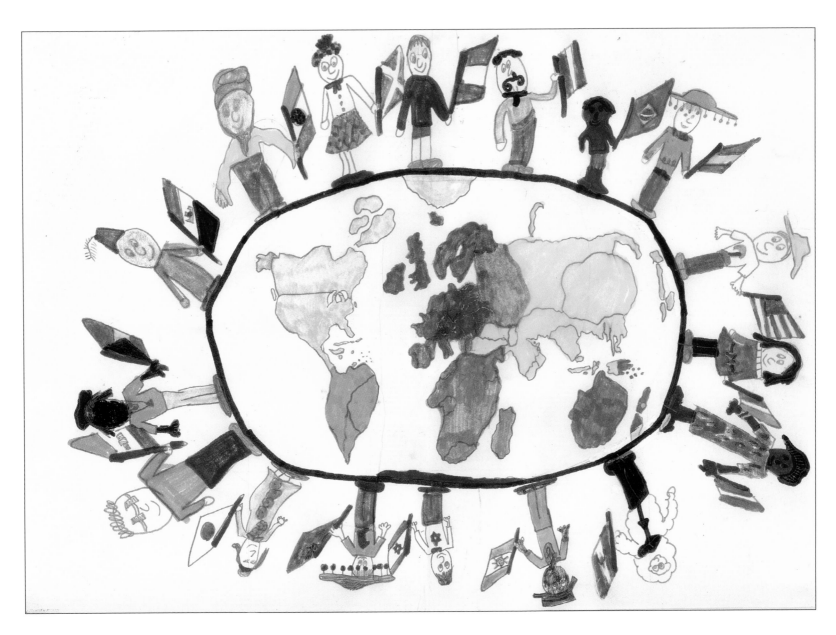

Children Unite!
Benjamin Nicholls
Age 7
United Kingdom
St. John's School, Keele, Staffordshire
1995

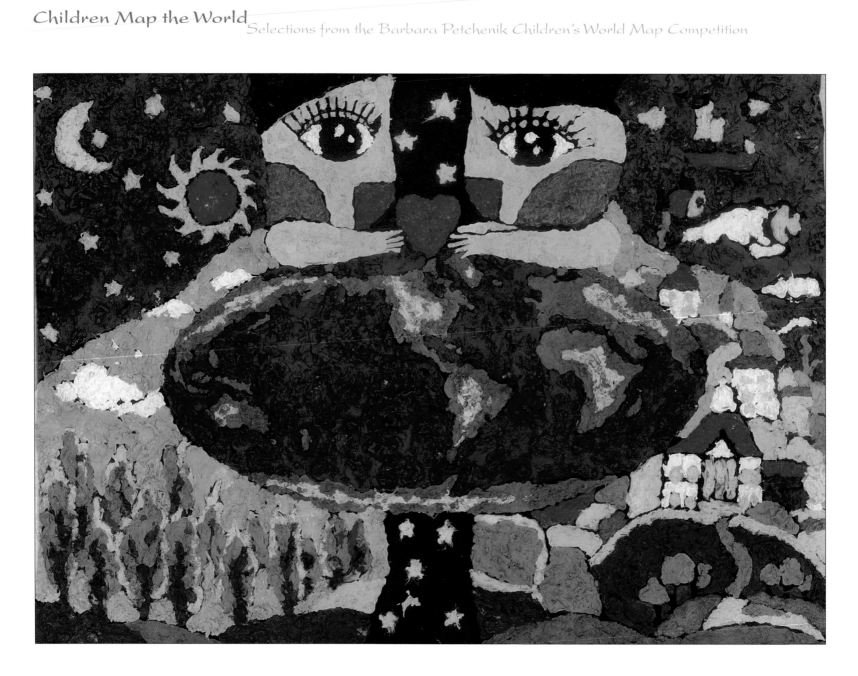

Children's Future Depends on the Changing World
Zichun Wei
Age 7
China
No. 11 Railway Primary School, Zhengzhou, Henan
2003

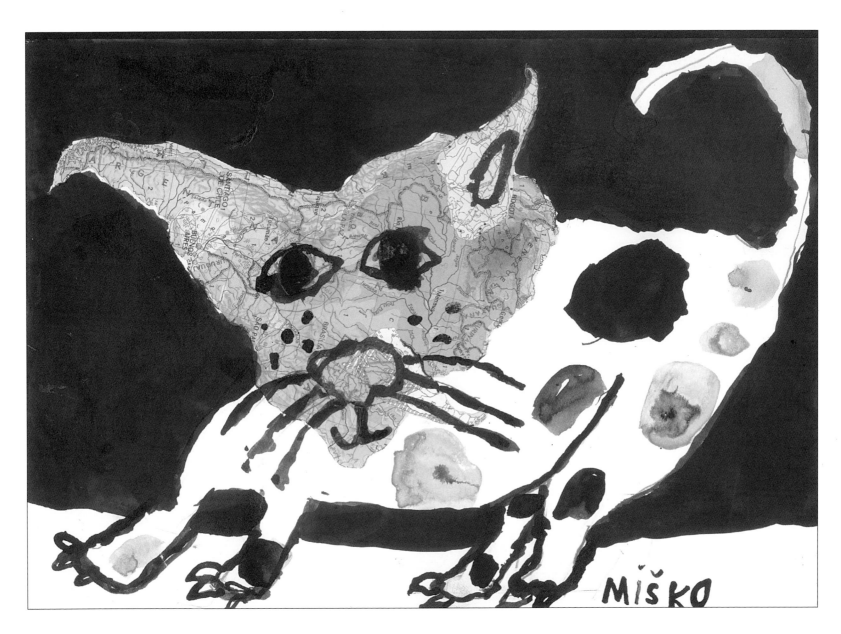

Untitled
Miško Sajko
Age 7
Slovak Republic
Zākladnā Skola, Bernolākovo
1993

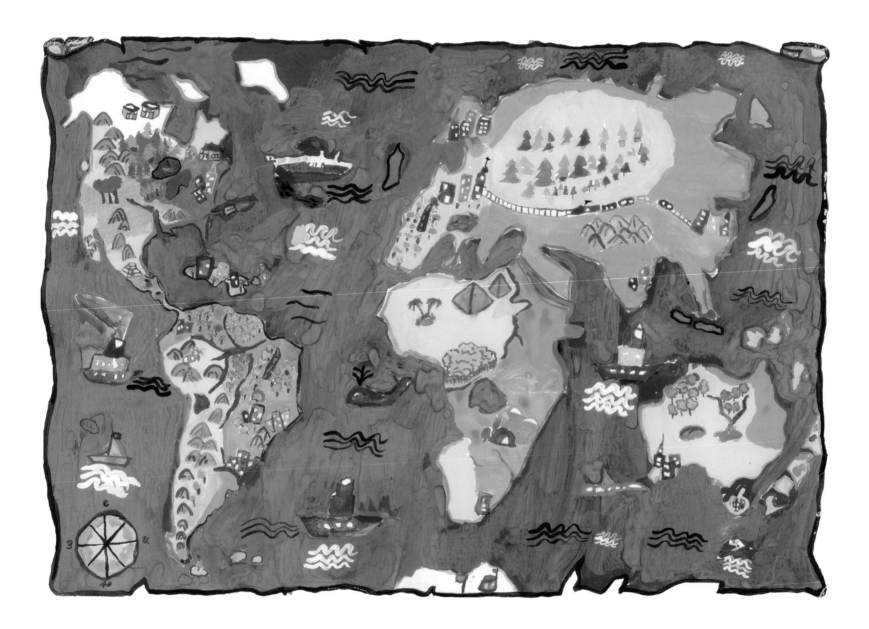

The Map of the World
Nikola Zlatanov
Age 7
Bulgaria
Children's Art Center, Sofia
1999

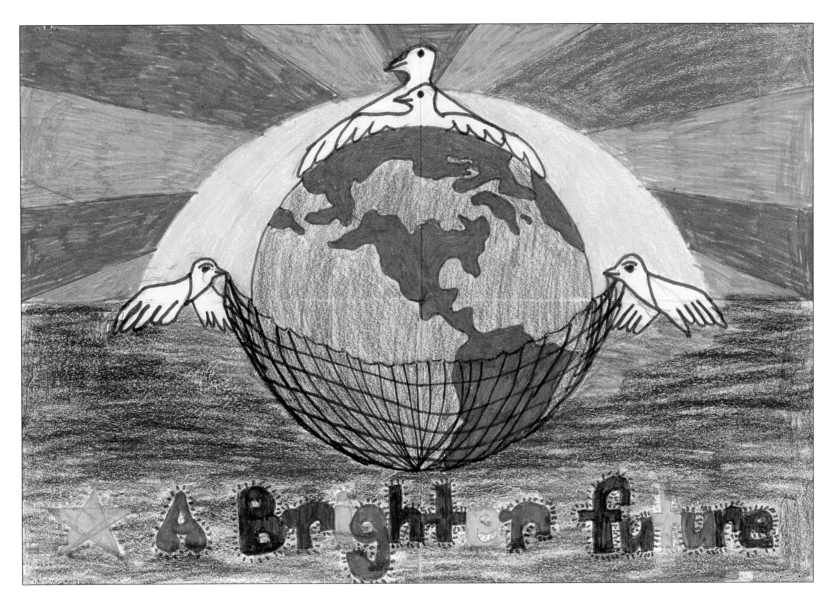

A Brighter Future
Maggie Tai
Age 7
Australia
South Thornlie Primary School
1997

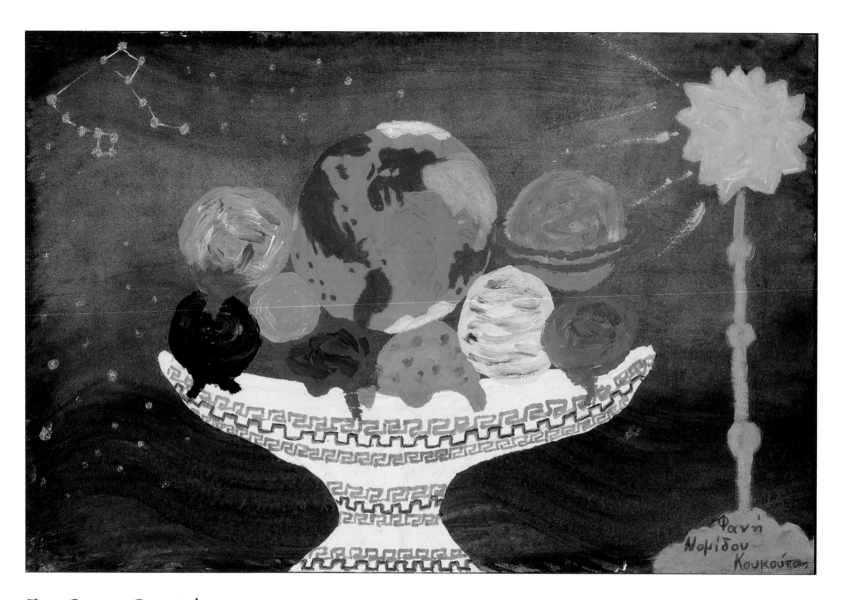

Ice Cream Special
Fani Nomidou-Koukoutsi
Age 8
Greece
Serres
1999

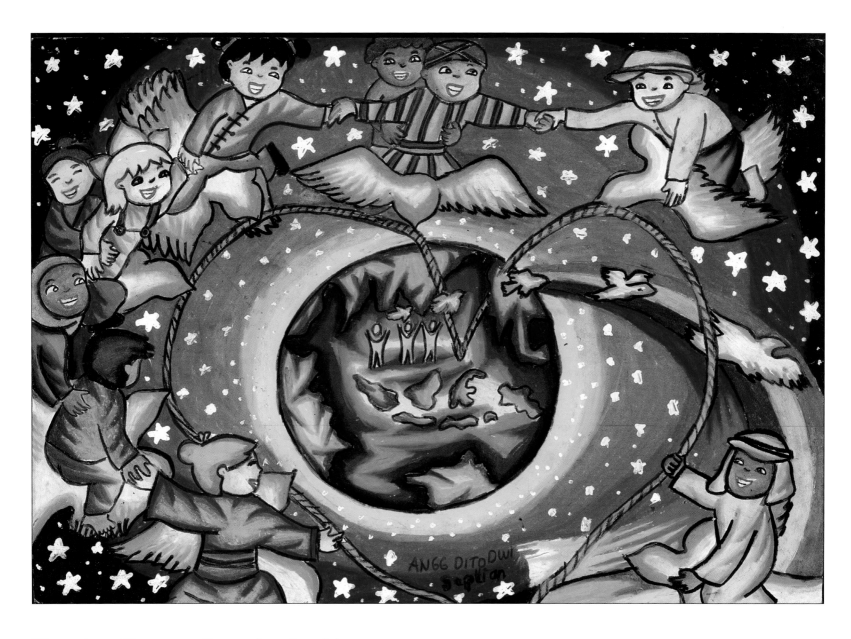

Together, Forever. Save the Earth!
Angg Dito Dwi Septian
Age 8
Indonesia
Al Amanah Elementary School, Jakarta
2003

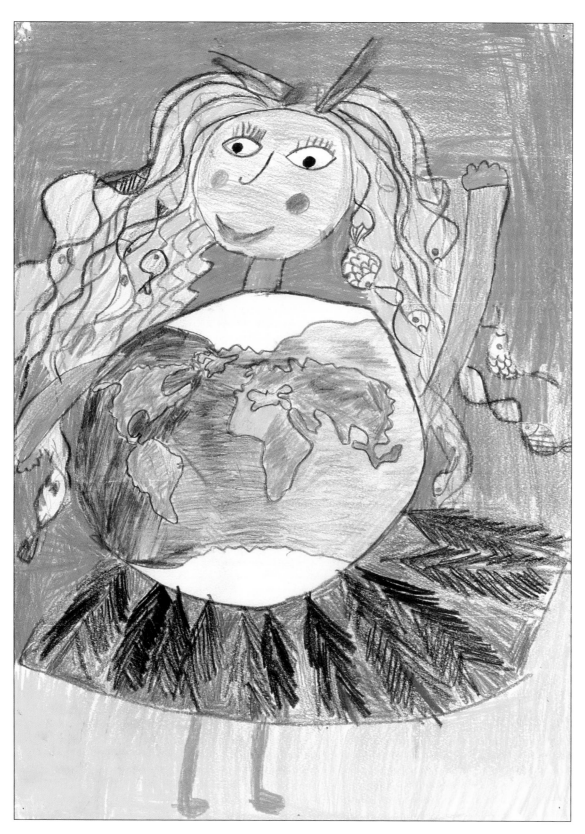

Our Beautiful Earth
Lucia Slacková
Age 9
Slovak Republic
Základná Škola, Banska Bystrica
1997

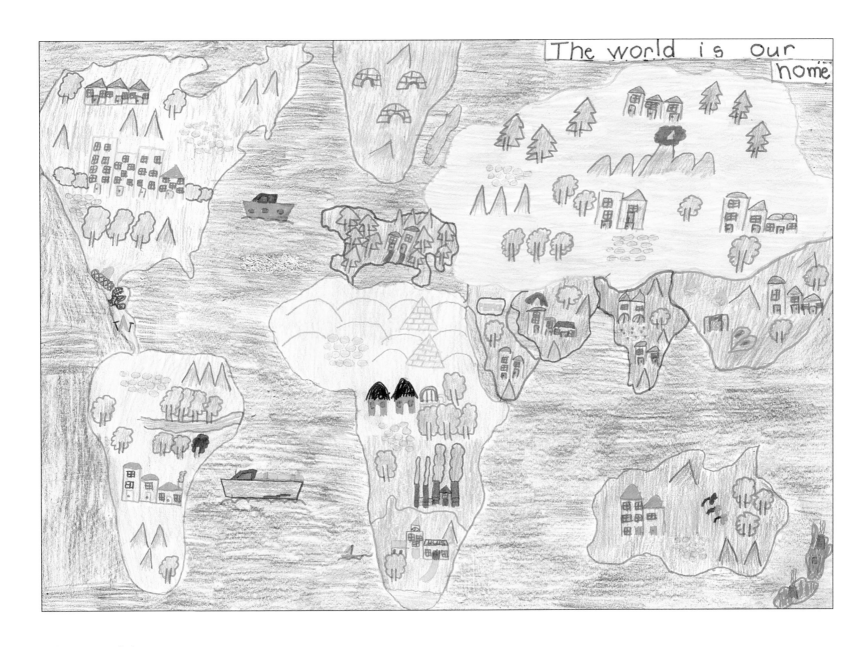

The World is Our Home
Hilde Pretorius
Age 9
South Africa
Volk Skool Magalies
1997

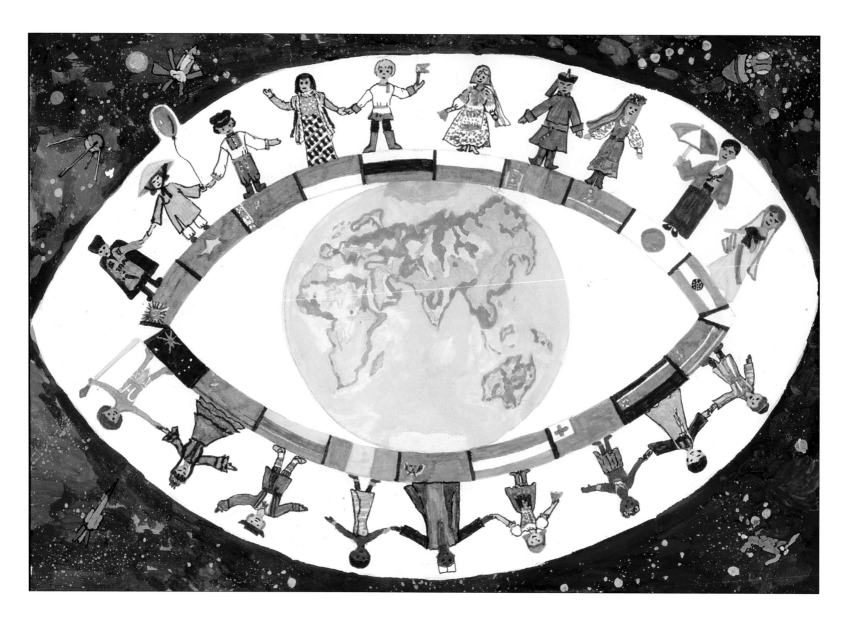

I See the World
Lena Golubeva
Age 9
Russian Federation
Children's Art School No. 4, Yekaterinburg
2003

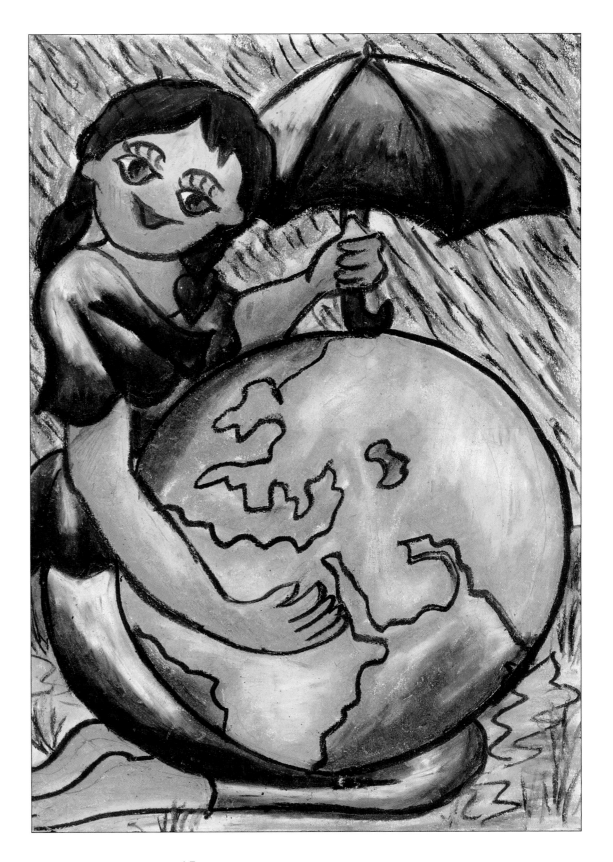

Untitled
Isuruni Kumanyaka
Age 9
Sri Lanka
Musaeus College, Colombo
2003

Age 10–11

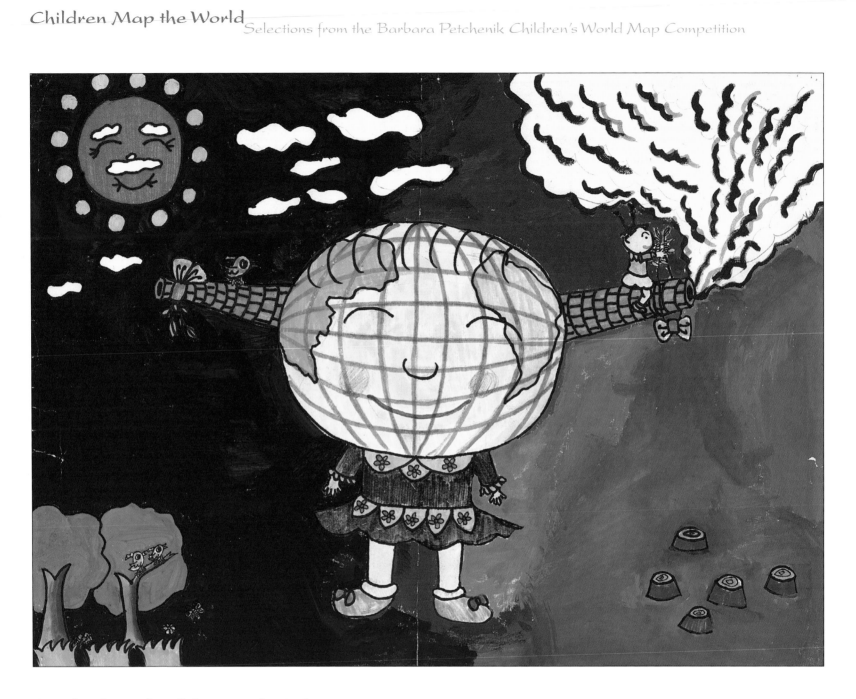

Tie the Braids of the Earth Girl
Tang Yuwen
Age 10
China
Wuce Campus, Wuhan University
2001

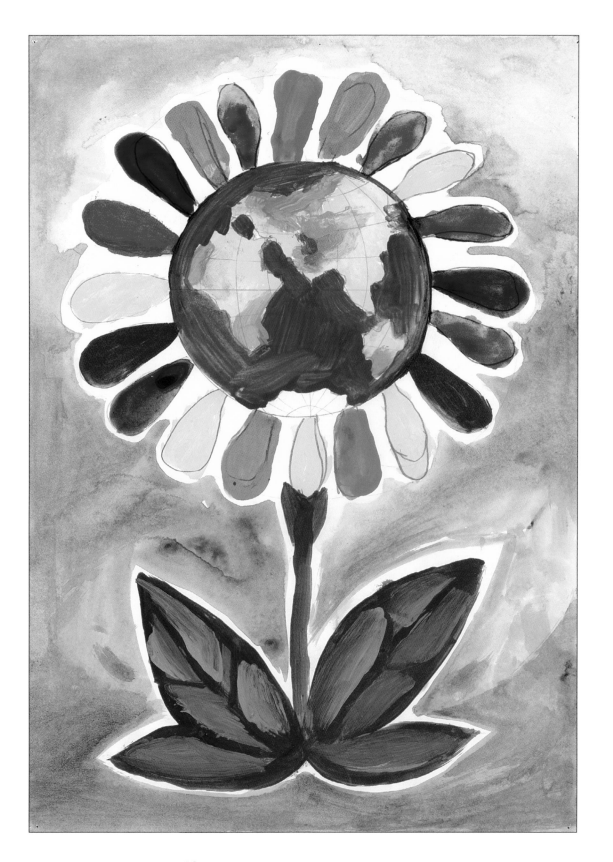

Earth
Leo Urevich Guhin
Age 10
Azerbaijan
Baku
1997

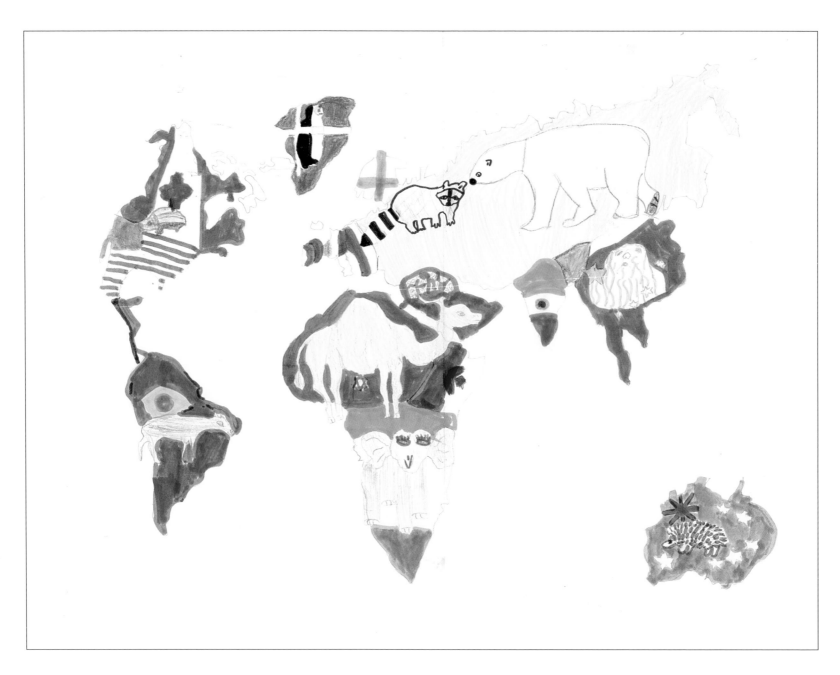

Untitled
Aicha Ait Oubanali
Age 10
France
Ecole Anatole France, Argenteuil
1995

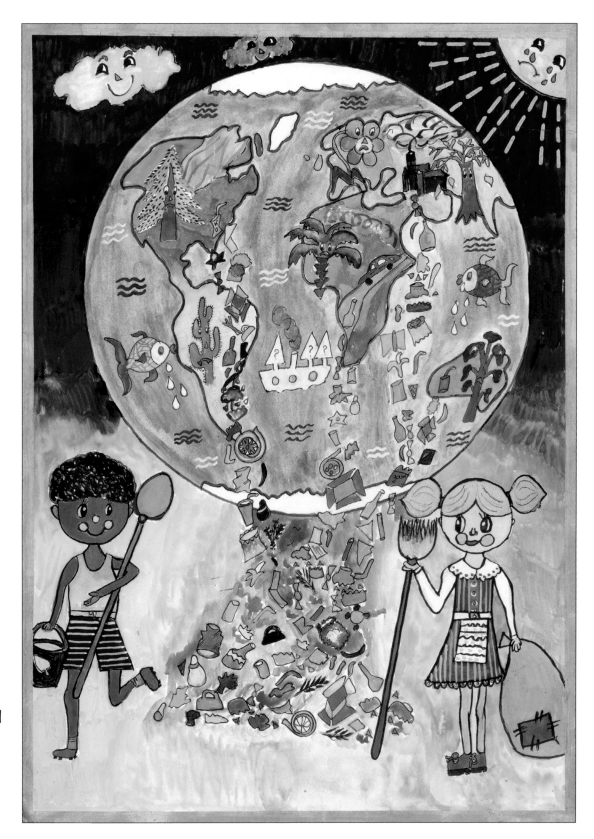

Let's Clean the World
Anelia Jotova
Age 10
Bulgaria
Children's Art Center, Sofia
1999

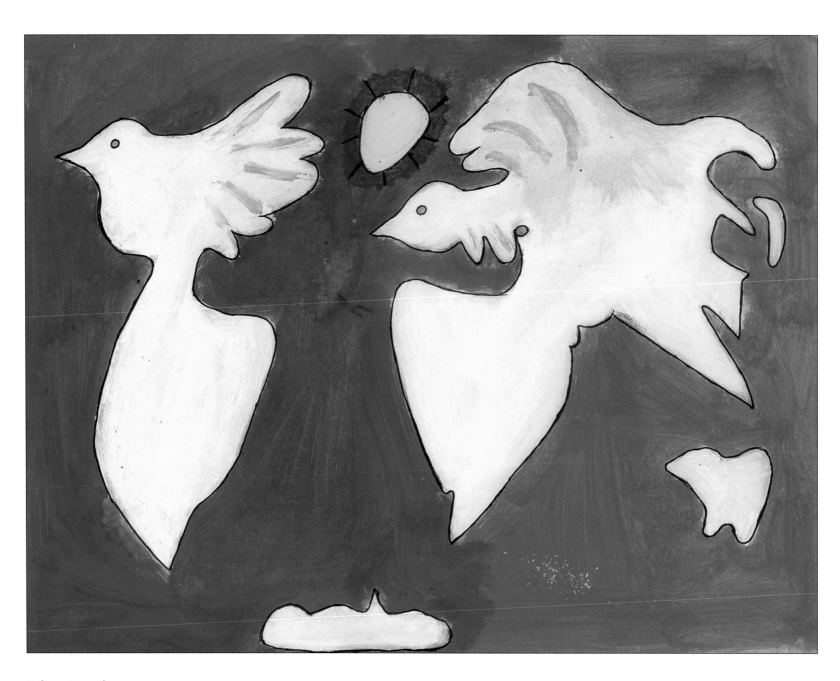

The Birds
Dimitris Michos
Age 10
Greece
Lamia
1999

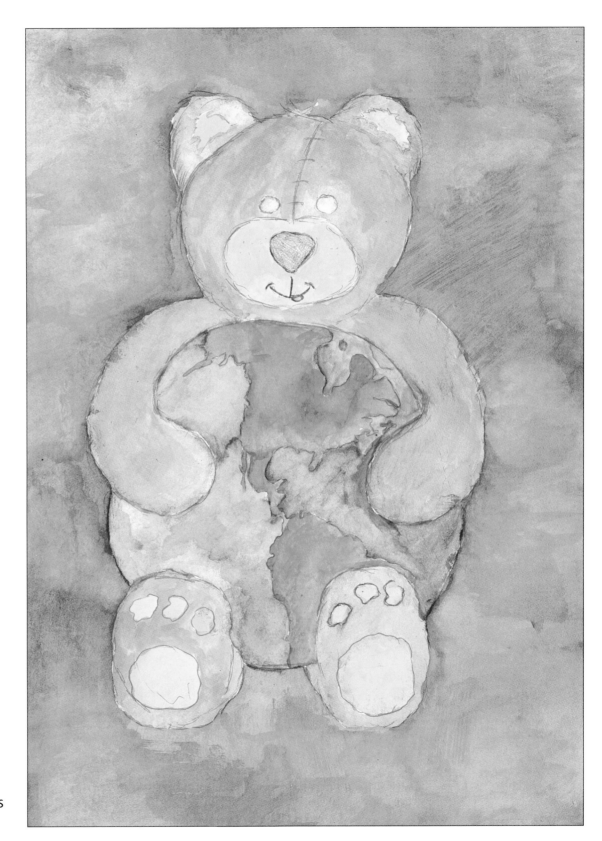

A Safe World
Silje Marie Kristiansen
Age 11
Norway
Helgerud School, Honefoss
1999

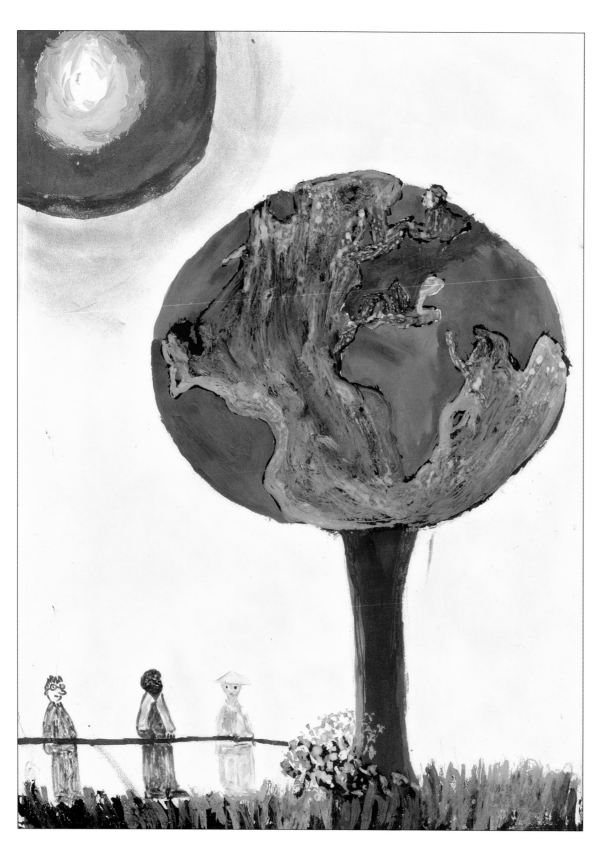

We Preserve the
Environment of the
Earth Together
Łukasz Rybak
Age 11
Poland
Warszawa
1995

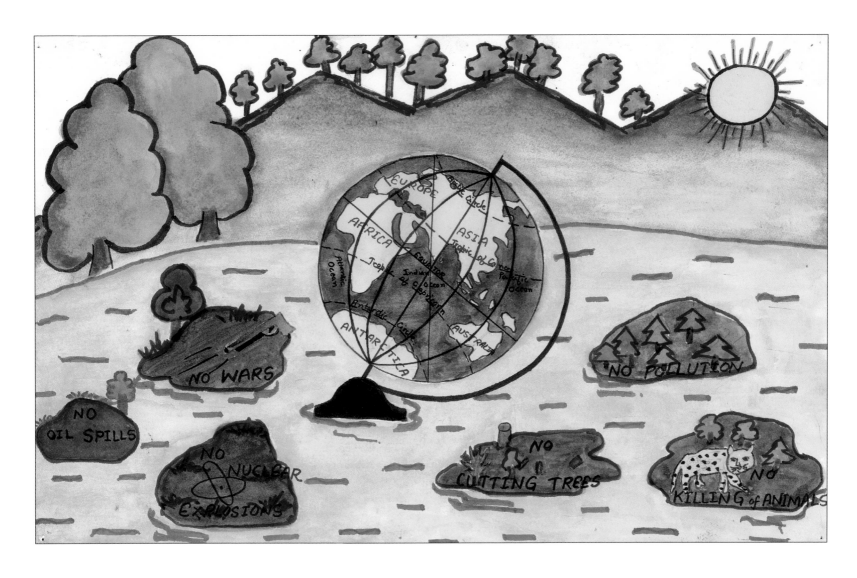

Save the Earth
Ankita Lamba
Age 11
India
Convent of Jesus and Mary, Dehra Dun, Uttaranchal
2001

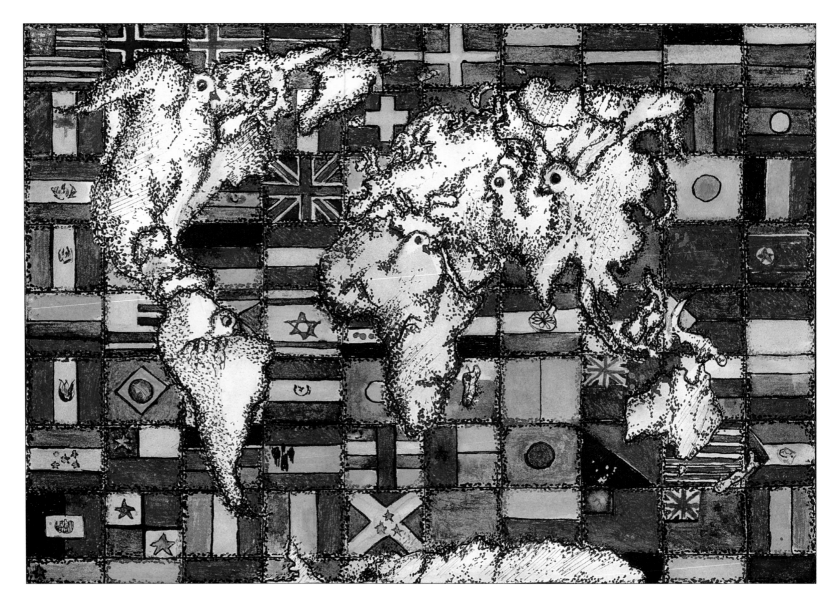

Peace in the World
Lekavicius Alfonsas
Age 11
Lithuania
Vilnius, Lithuania
1993

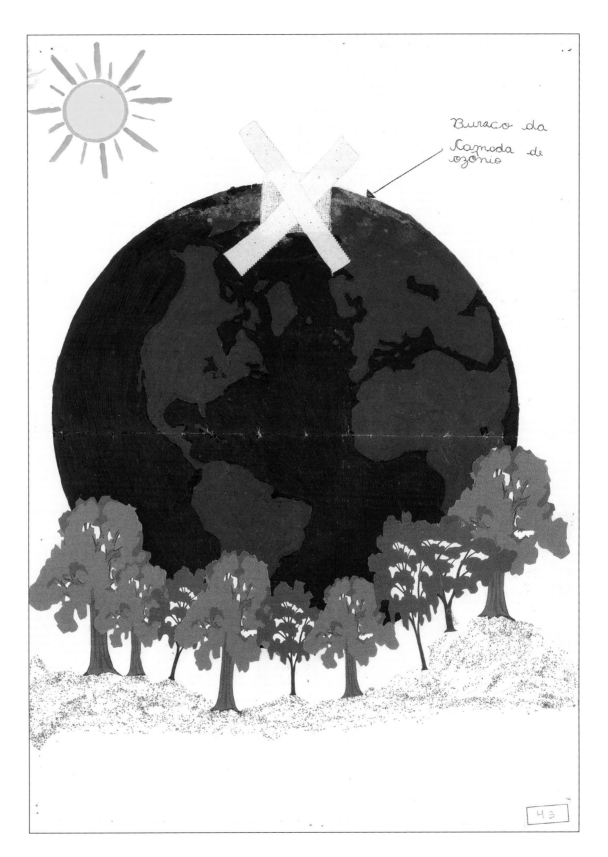

Save the Earth
Jacqueline C. Camargo
Age 11
Brazil
Travessa Jacob Budel, 36,
Bocaiuva do Sul
2001

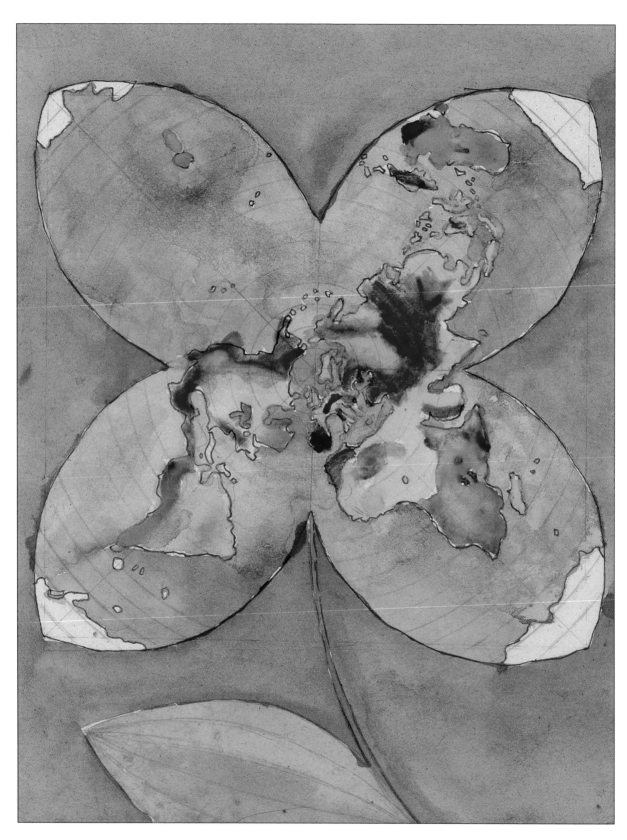

Flower World
Jósef Bodor
Age 11
Hungary
"Szegedi K. István"
Secondary School,
Mezötúr. Kossuth Lajos
út 2
1999

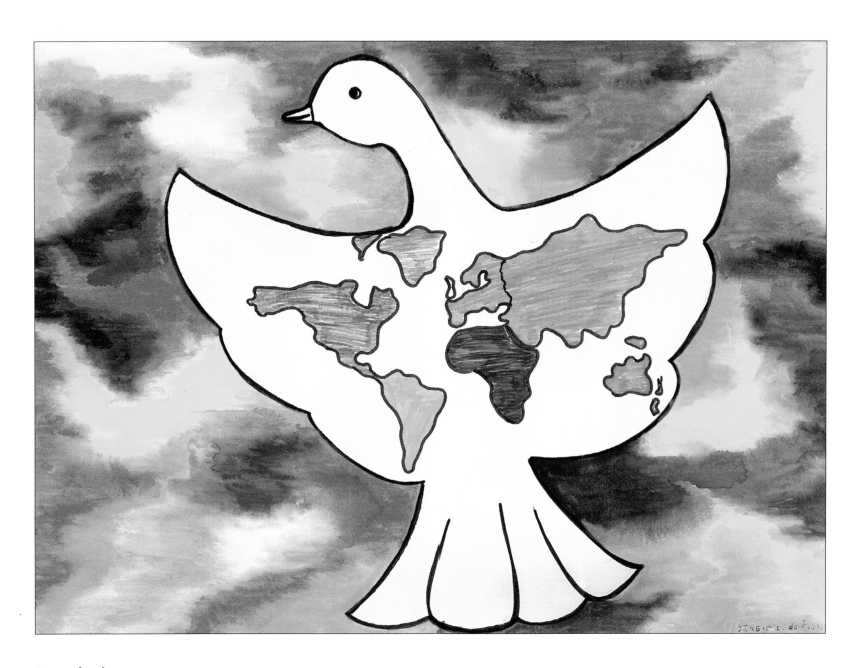

Untitled
Sergio Castany de Fiori
Age 11
Brazil
Colegio Miguel de Cervantes, San Paulo
1993

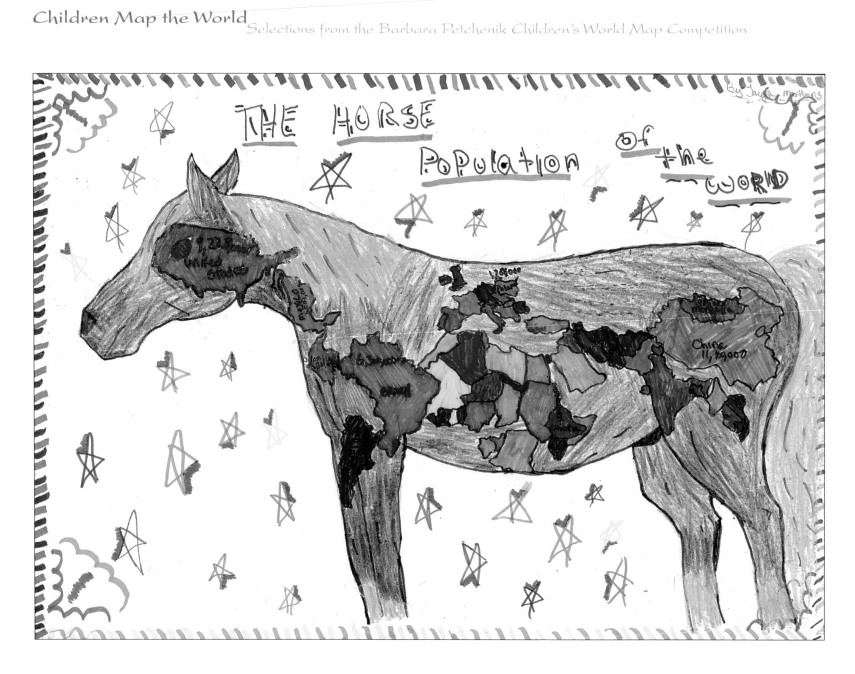

The Horse Population of the World
Taiga Marthens
Age 11
United States
Sussex School, Missoula, Montana
1993

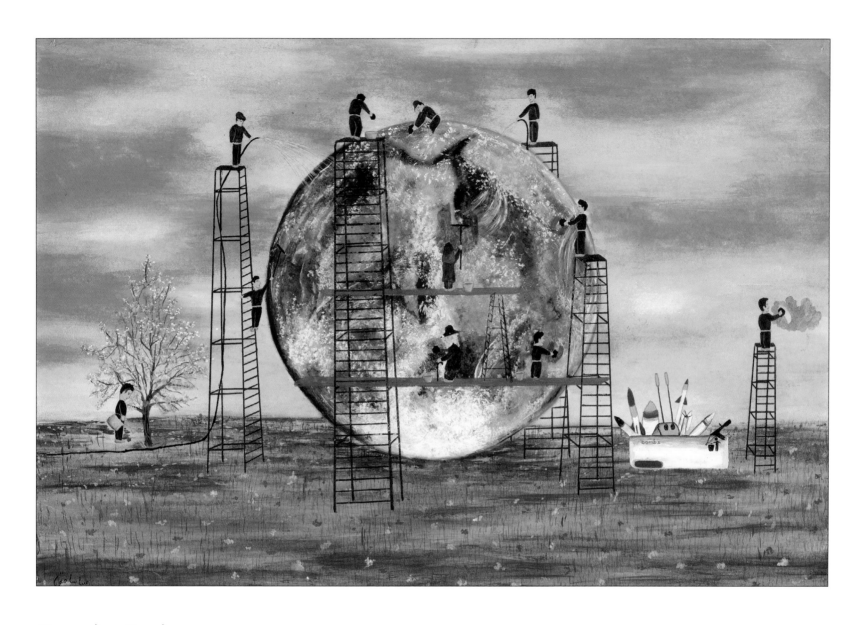

Save the Earth
Saba Sameti
Age 11
Iran
Edalat Secondary School, Isfahan University Campus
2001

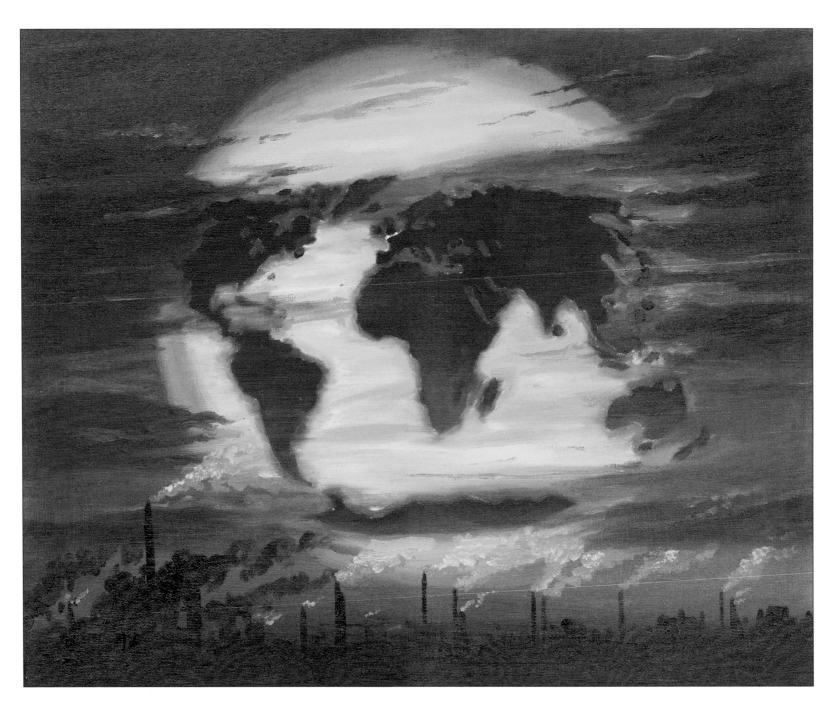

Is the Earth's Future Going to Be Like This?
Jacek Majewski
Age 11
Poland
Święcice K. Błonia
1997

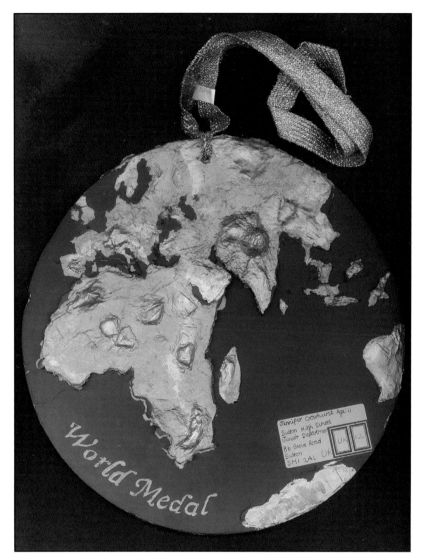 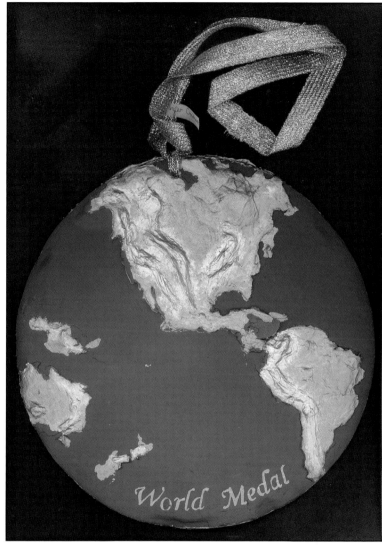

World Medal
Jennifer Crowhurst
Age 11
United Kingdom
Sutton High School, Junior Department, Sutton, Surrey
2001

Age 12

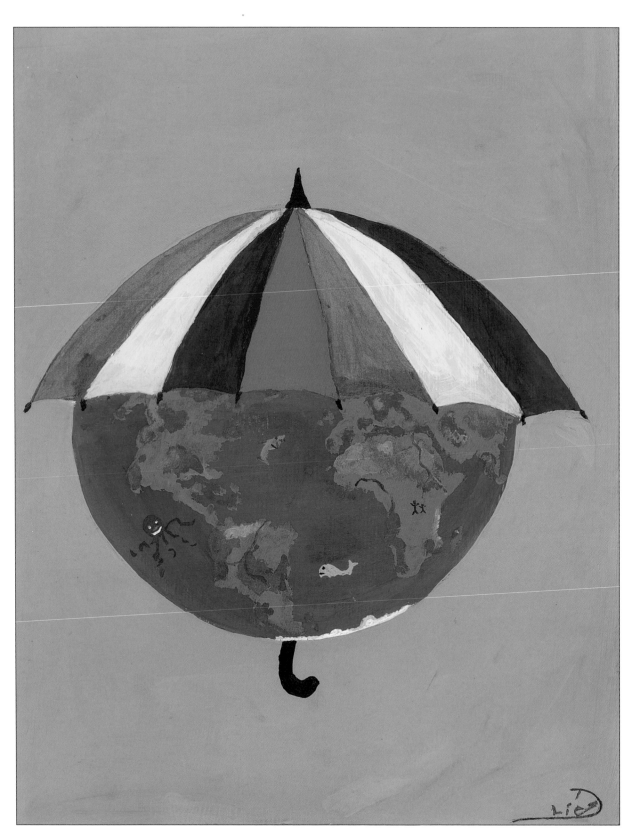

A Protective
Umbrella for Our
Earth
Dominic Lier
Age 12
Germany
Regelschule Unstruttal,
Ammern
2003

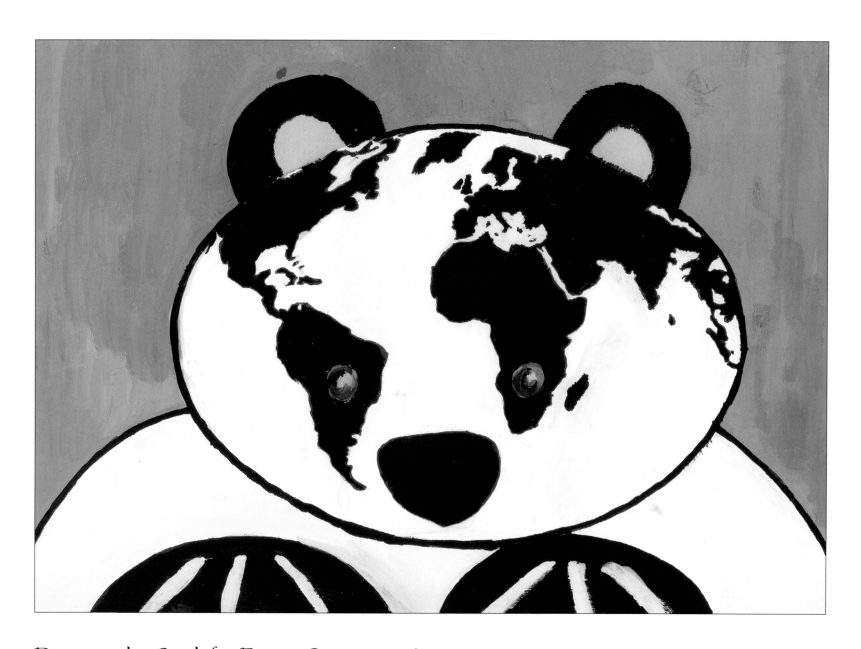

Preserve the Earth for Future Generations!
(Pandaworld Is a Better World for Children)
Gabriella Fink, György Viszti
Age12
Hungary
Béry Balogh Ádám Secondary School, Tamási
2003

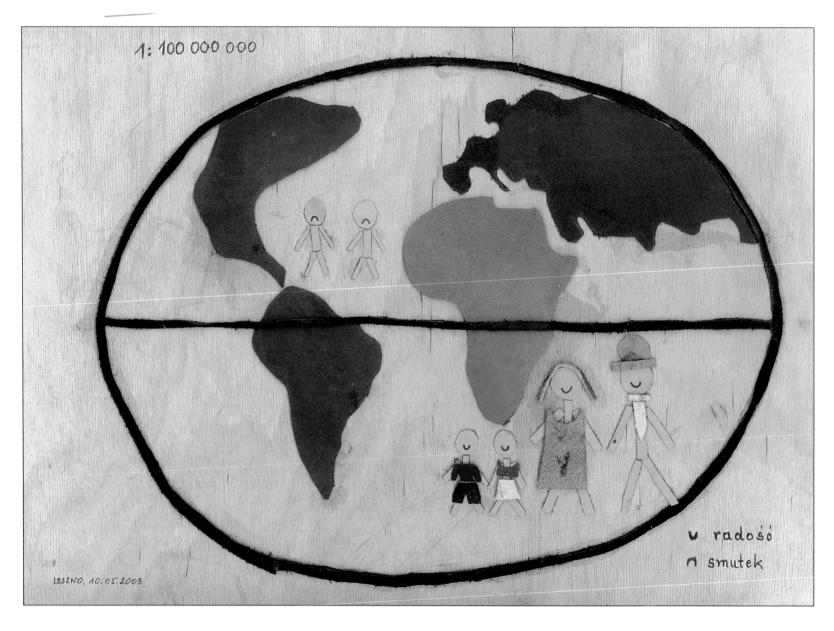

How Good with Parents
Patrycja Matuszewska
Age 12
Poland
Szkola Podstawowa im. Stefana Batorego, Leszno
2003

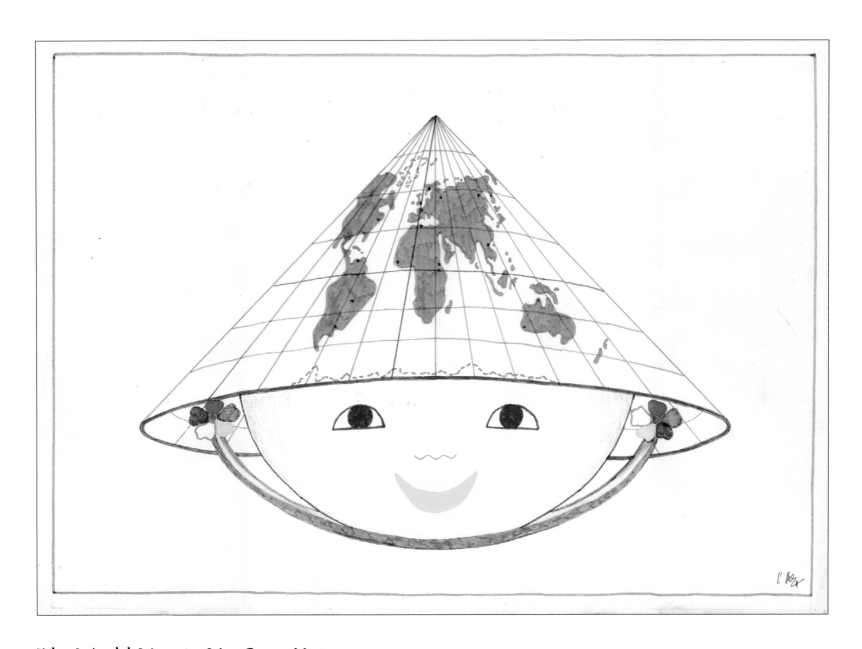

The World Map in My Cone Hat
Nguyen Thi Phoung Anh
Age 12
Vietnam
School Amsterdam, Hanoi
1995

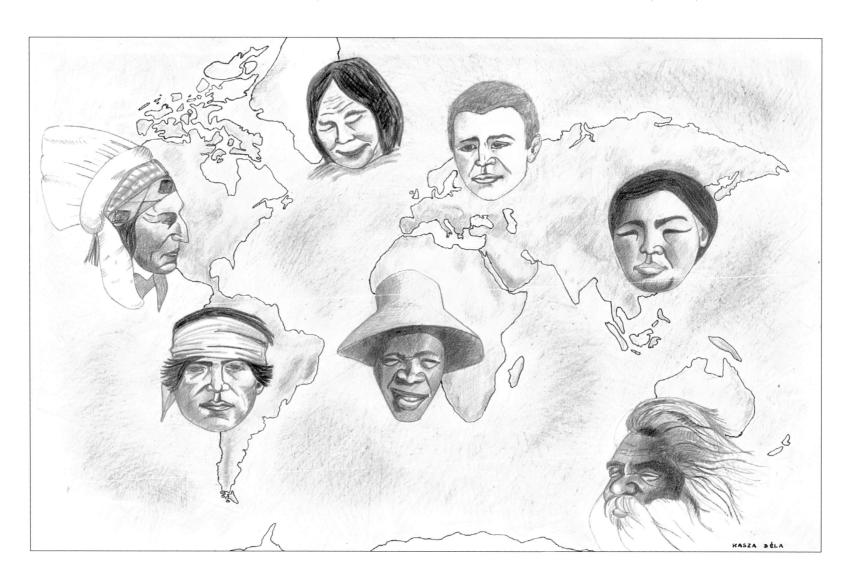

Untitled
Kasza Béla
Age 12
Hungary
1993

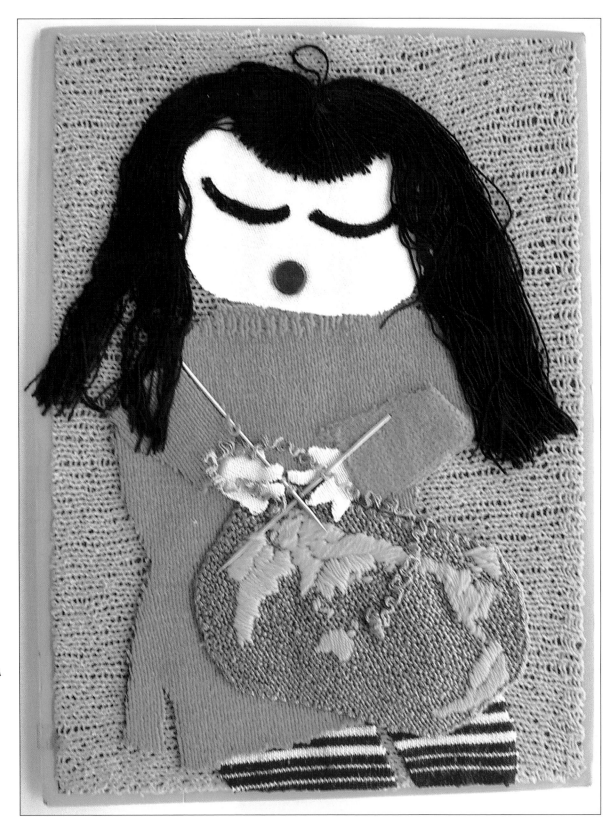

Mother Is Weaving a New World for Us
Junchao Wang
Age 12
China
Daqing Jingyuan Middle School, Heilongjiang
2003

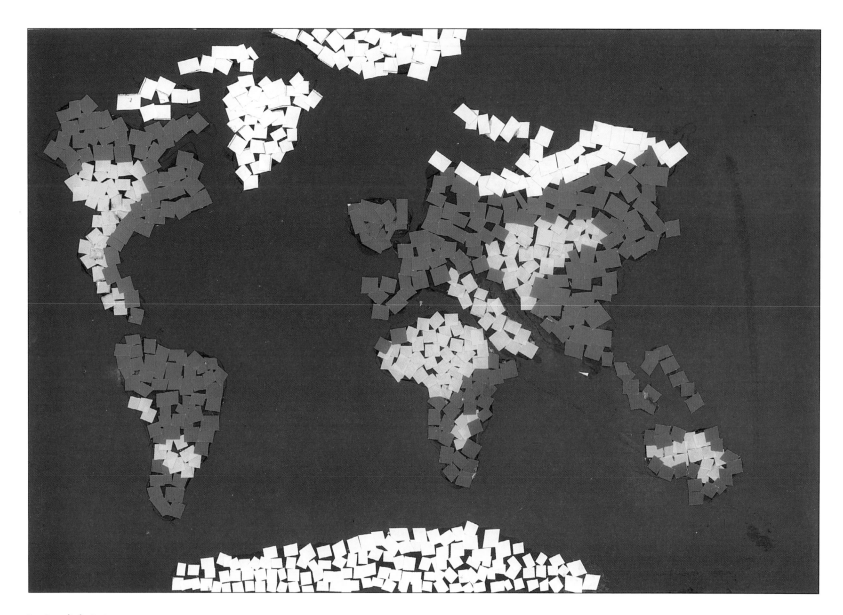

World Map
Ranko Vuković
Age 12
Croatia
OS Antun Mihanović 35, Mihanovićeva
1999

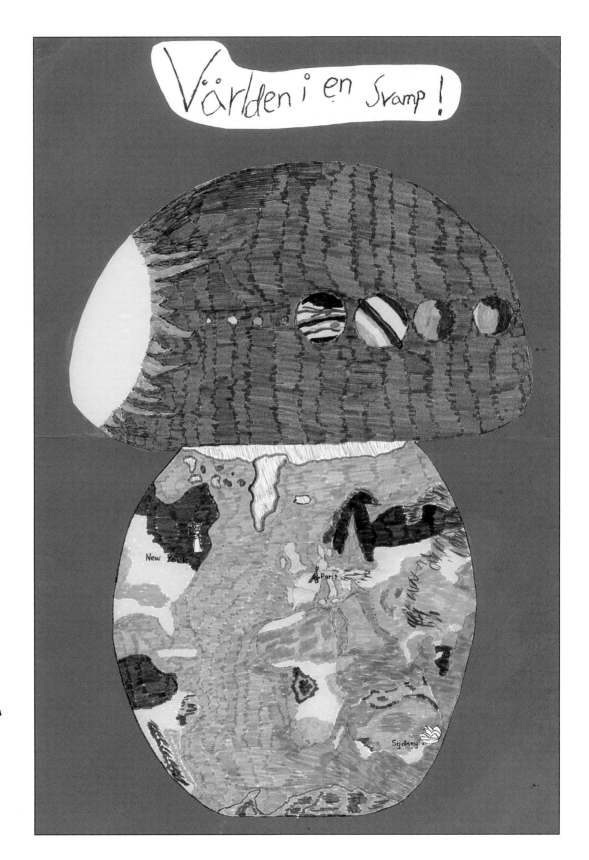

The World in a Mushroom
Julia Norgård, Josefin Alverup,
Emelie Ohlsson, Mikaela Almberg
Age 12
Sweden
Villa Skolan, Åhus
2001

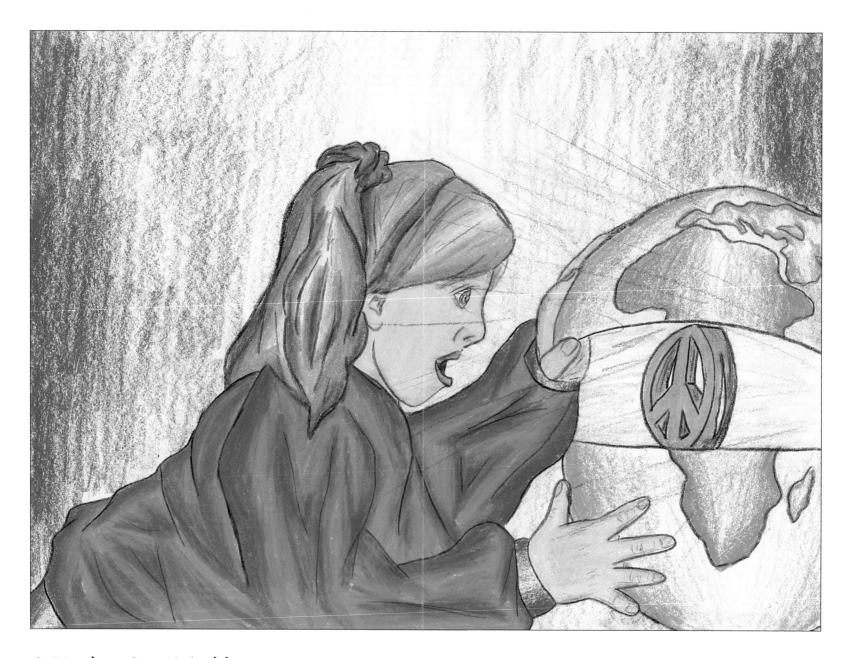

A Nuclear Free World
Kathleen Barry
Age 12
Canada
Holy Trinity High School, Kanata, Ontario
1993

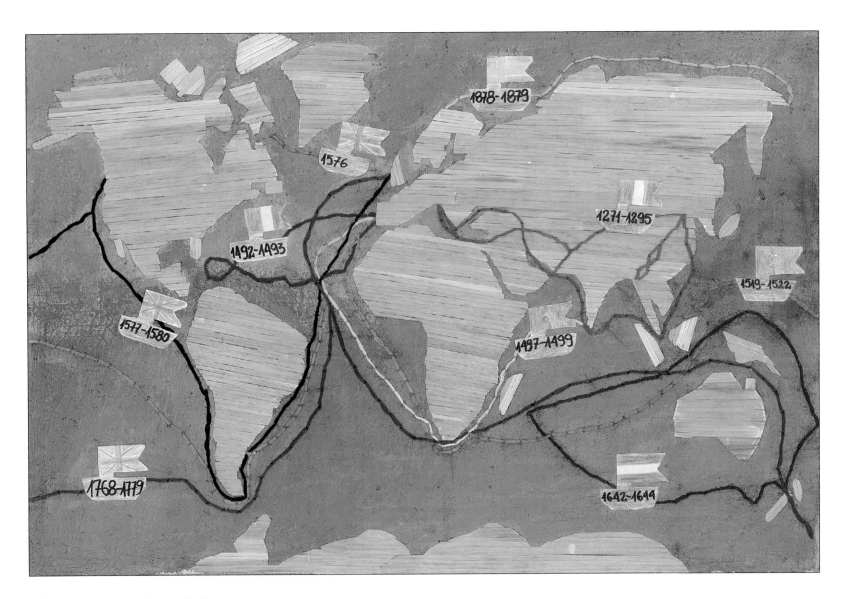

The Geographical Discoveries
Julita Trzaskowska
Age 12
Poland
Chotomow/Warszawa
1995

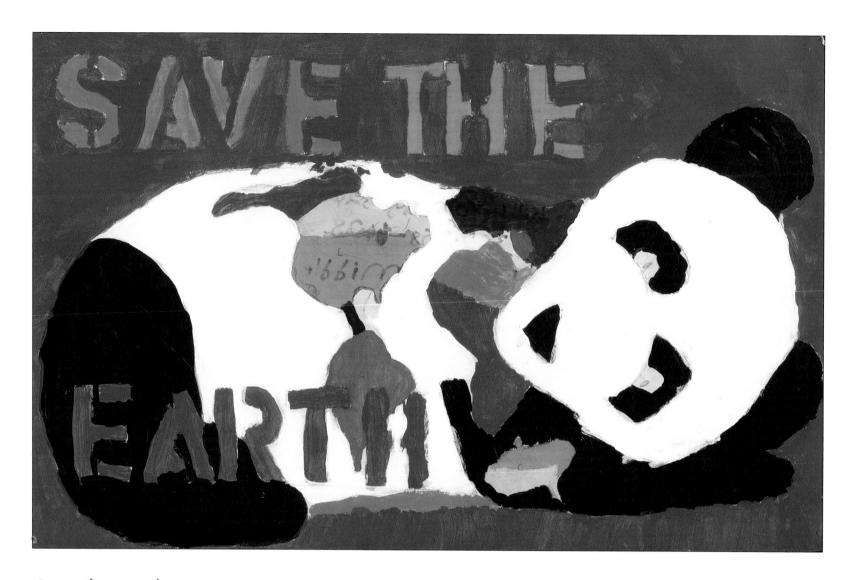

Save the Earth
Sierra Rodeman
Age 12
United States
Douglas Middle School, Douglas, Wyoming
2001

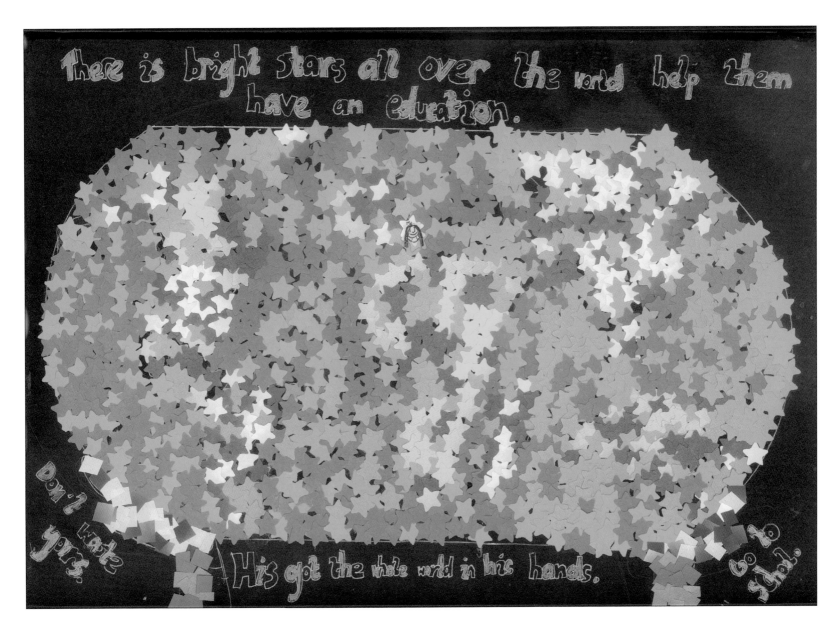

Bright Star
Jessica Defoe
Age 12
United Kingdom
Connaught School, London
2003

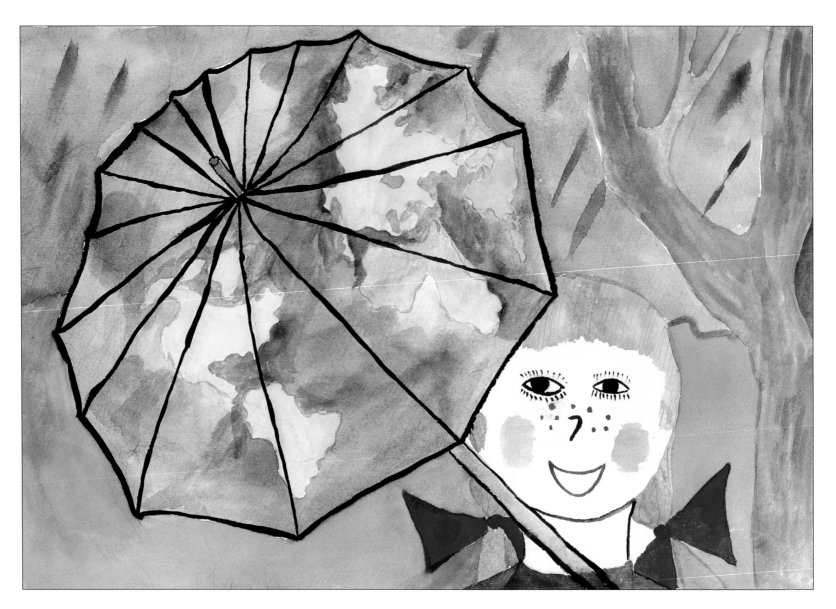

Our Common House Is Planet Earth
Karpuk Larysa
Age 12
Ukraine
I-III Levels Comprehensive School No.8 Kovel, Volynska obl.
1997

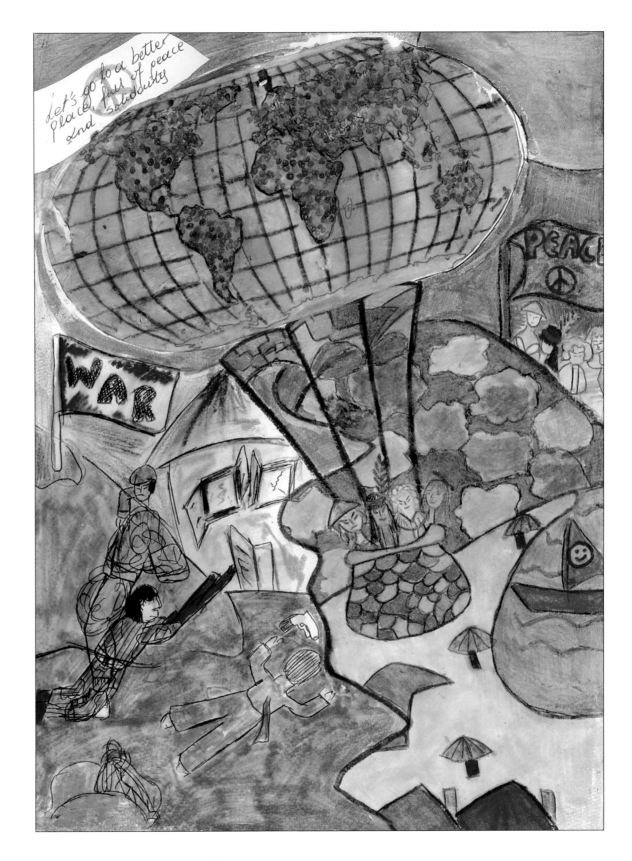

Let's Go to a Better
Place, Full of Peace
and Solidarity
Katerina Sarantopoulou
Age 12
Greece
Messini
1999

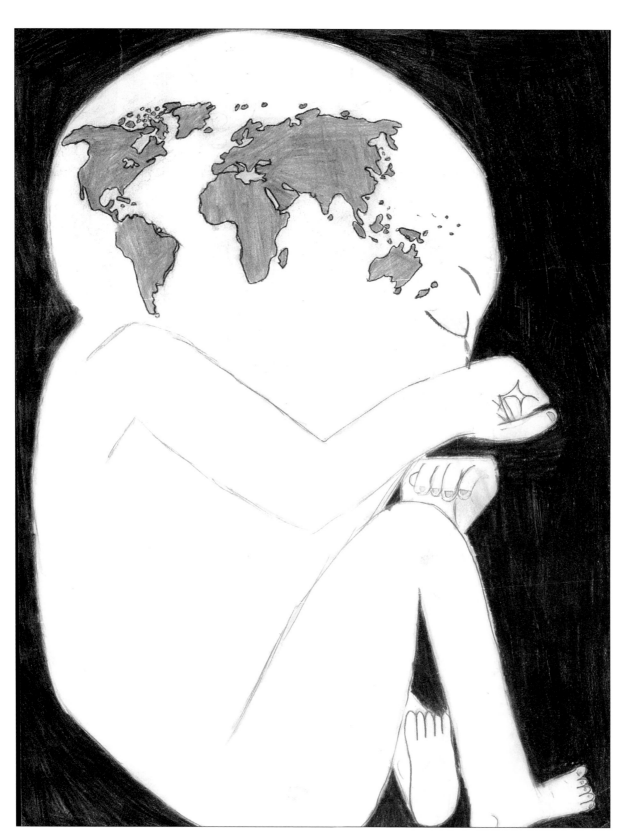

The Future of
the World Is on
Children
Leone Meireles Cardoso
Age 12
Brazil
Escola de Educação Básica
e Profissional Fundação
Bradesco Ceilândia,
Ceilândia DF
2003

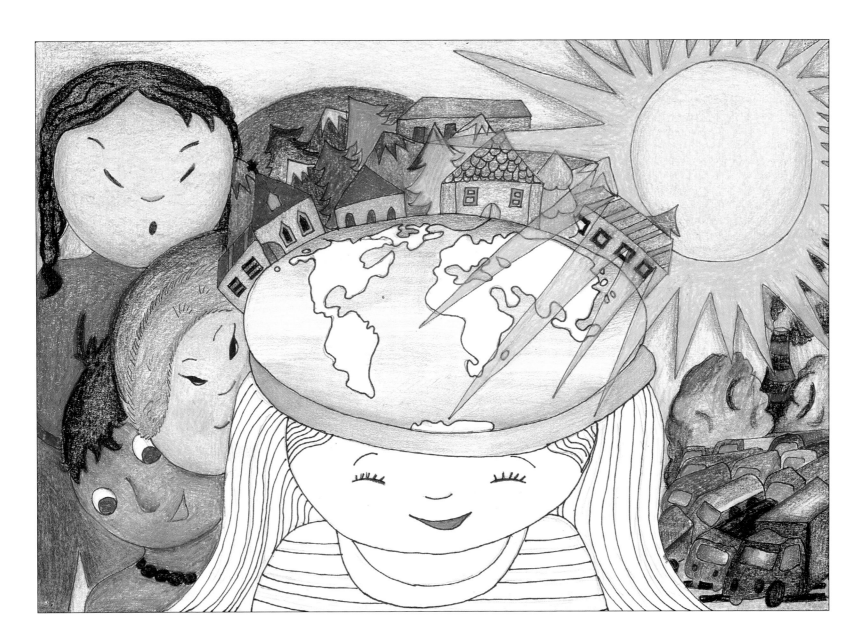

Untitled
Michaela Klimentovā
Age 12
Slovak Republic
Základná škola, Zarnovica
2001

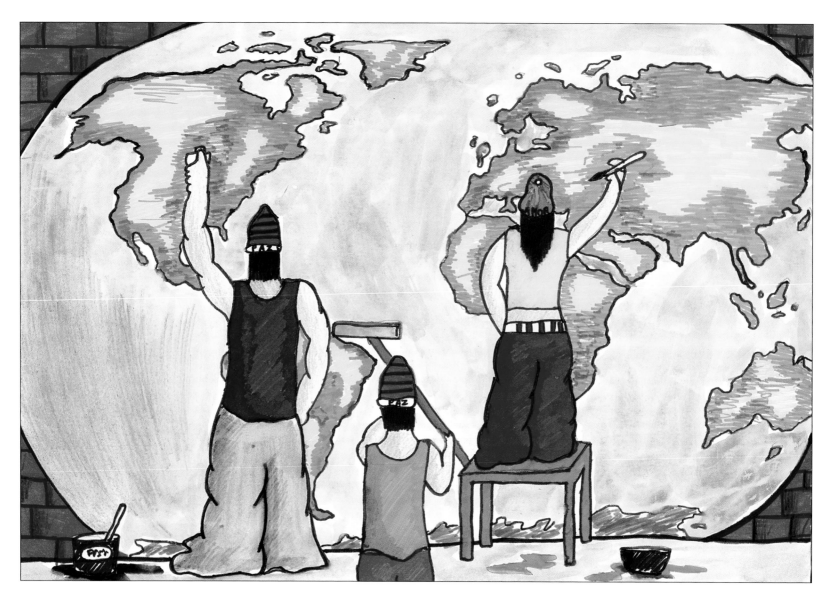

Urban Mural
Luciano Castro Saraiva
Age 12
Brazil
Fundação Bradesco - Escola de Educação Básica e Profissional
'Embaixador Espedito de Freitas Resende', Teresina
2003

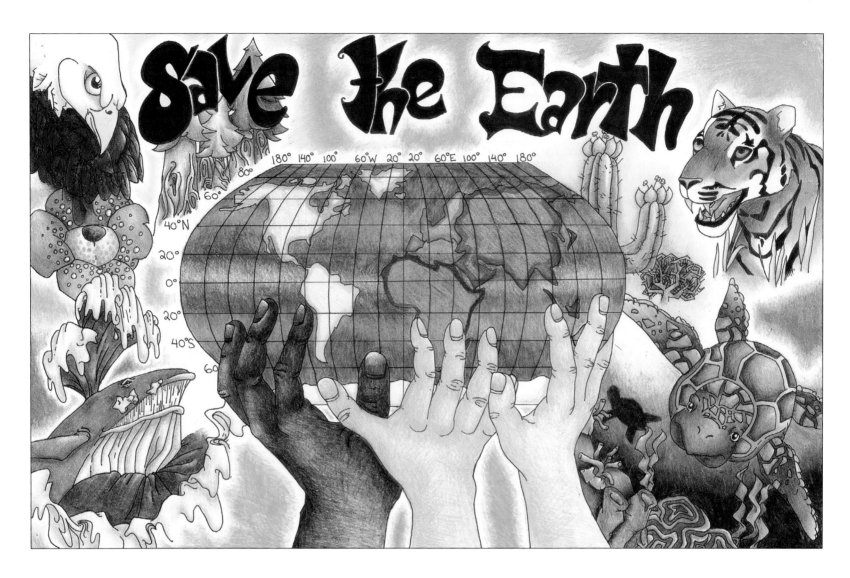

Save the Earth
Patricia Lan
Age 12
Canada
Glenlyon-Norfolk School Junior Girls Campus, Victoria, British Columbia
2001

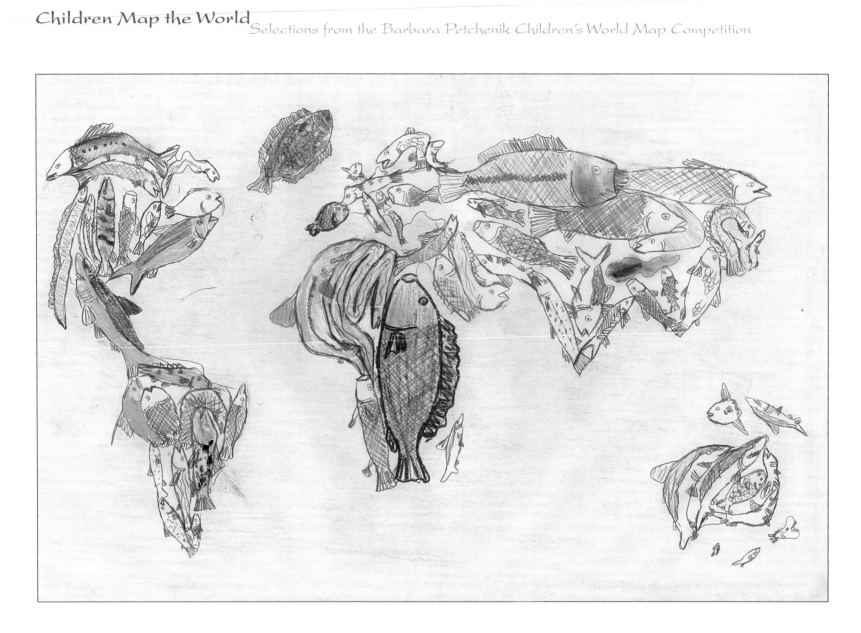

Untitled
Andre Fernando Vasconcellos
Age 12
Brazil
Colegio Santa Cruz
1995

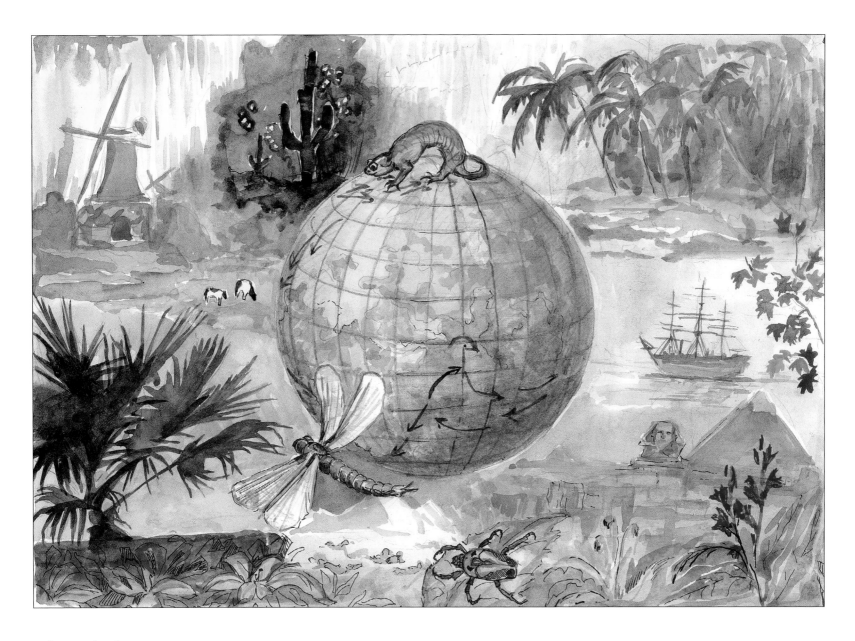

Cherish Our Nature
Zhenya Vidyapina
Age 12
Russian Federation
Moscow Academic Art Lyceum of the Russian Art Academy, Moscow
2003

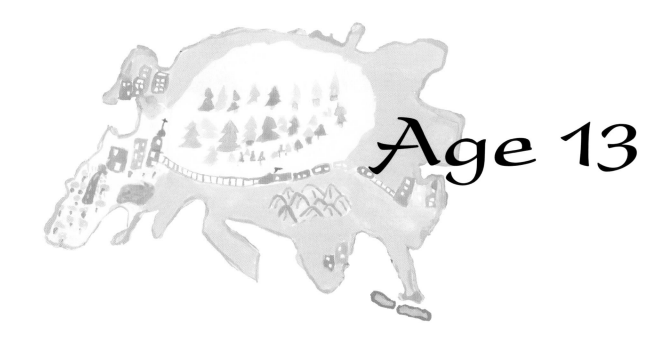

Age 13

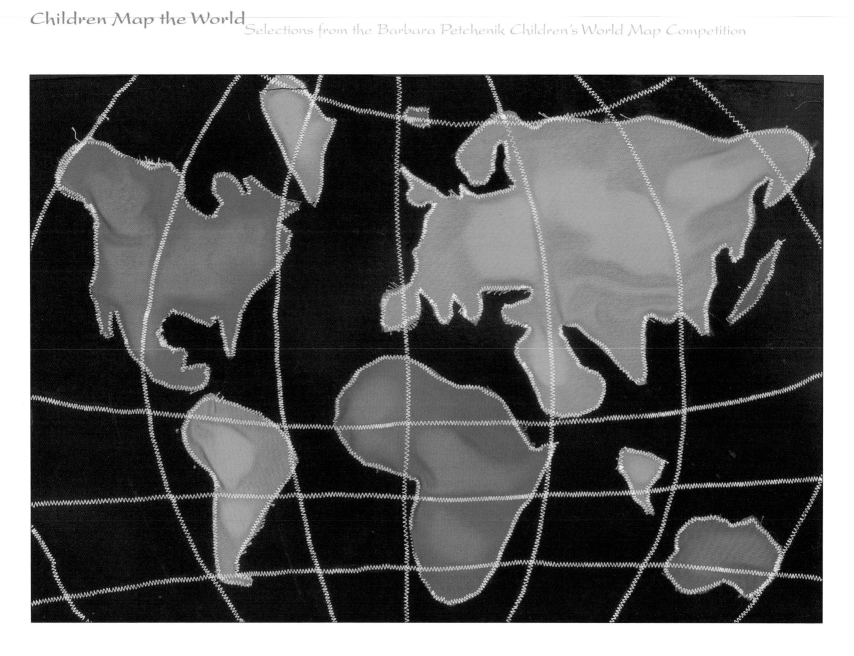

The Criss-cross World
Lovisa Engberg
Age 13
Sweden
Gavle
2001

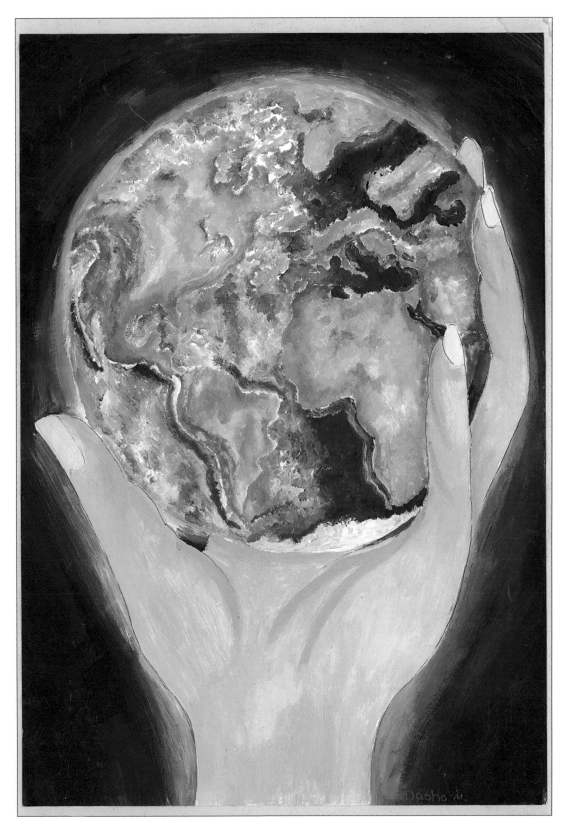

The World Is in Your Hand
—Preserve It
Zoya Praslov
Age 13
Israel
Ayyelet HaShahar, Tiberias
2001

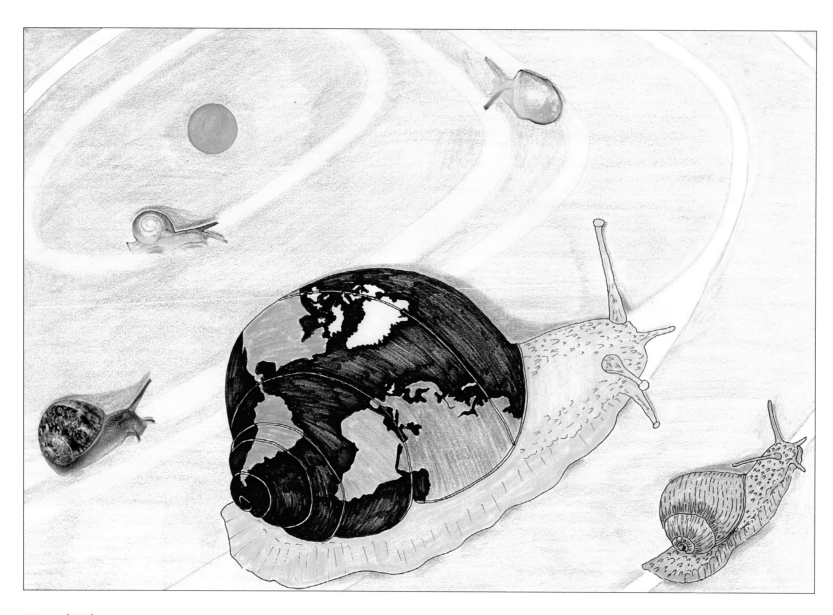

Snail Planet
Lazar Cvjetković
Age 13
Croatia
OŠ Dr. Andrija Mohorovičić, Matulji
2001

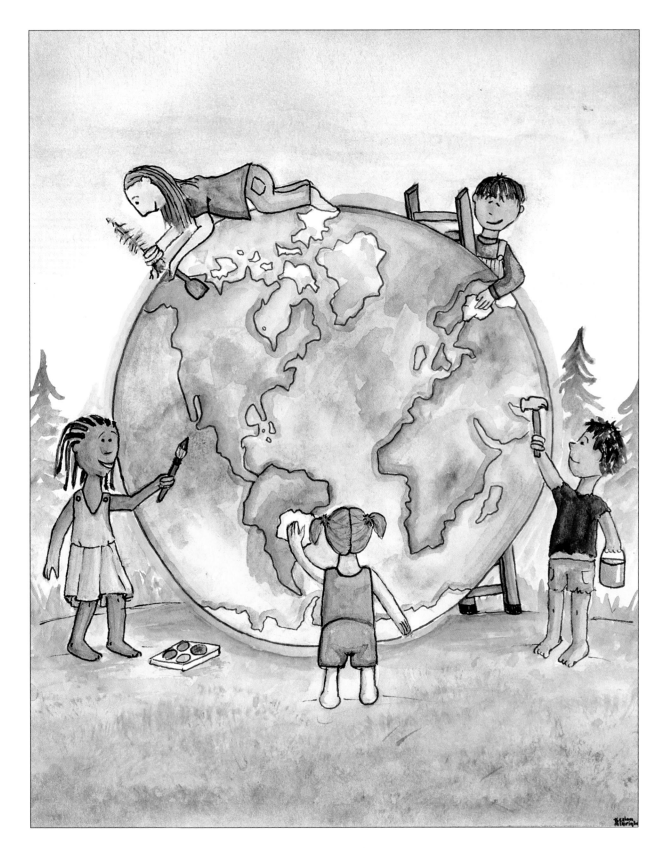

Rebuilding Our World
Keelan Albright
Age 13
Canada
Bishop Pinkham Junior
High School, Calgary,
Alberta
2003

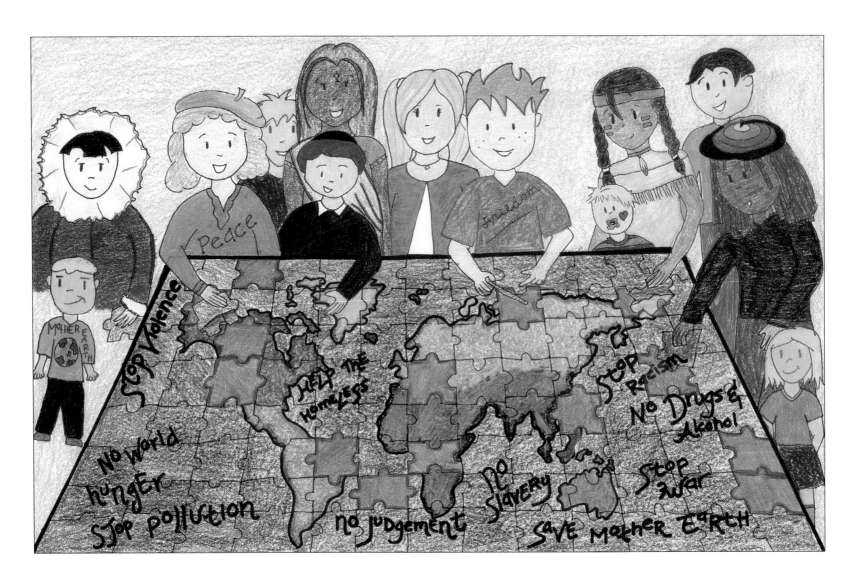

United Pieces
Rachelle Domingo, Michael Estalilla, Argielica Jumarang, Catherine Ambicki
Ages 13 and 14
Canada
St. Philip School, Mississauga, Ontario
2003

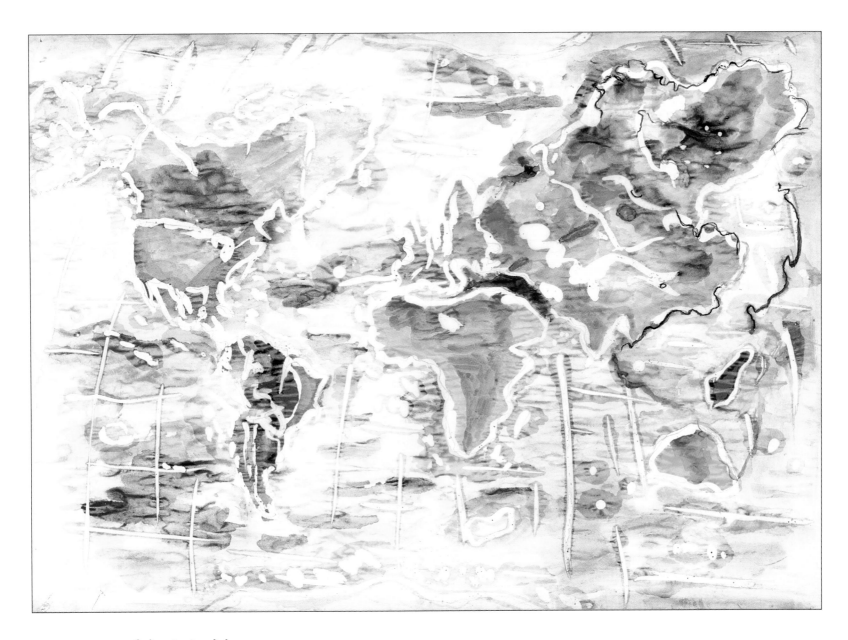

Eco Map of the World
Amela Kičić
Age 13
Croatia
I. Osnovna skola Varaždin
2001

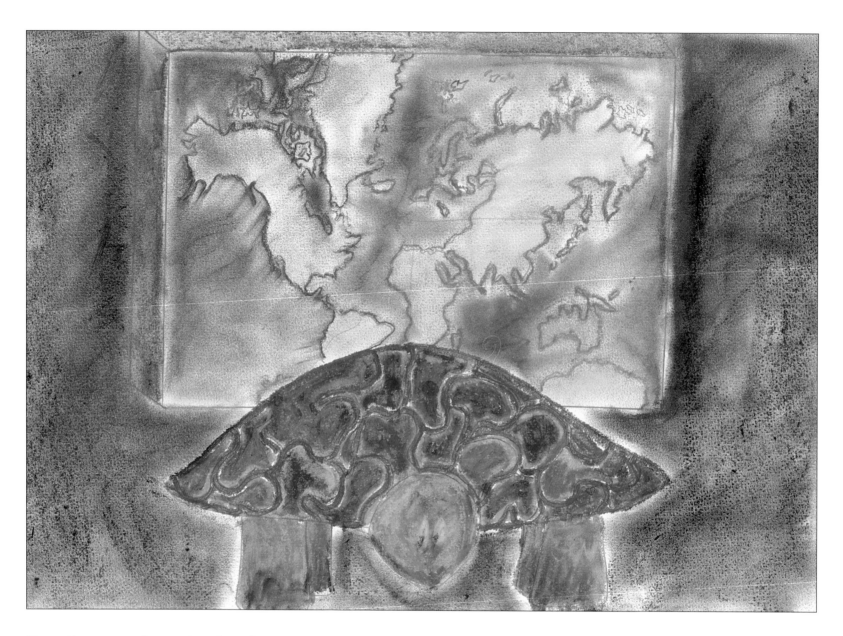

Past Time without Technology
Lucia Barcelo
Age 13
Argentina
San Pablo Apostol, Callejon de Gingins, Prov del Neuquén
2001

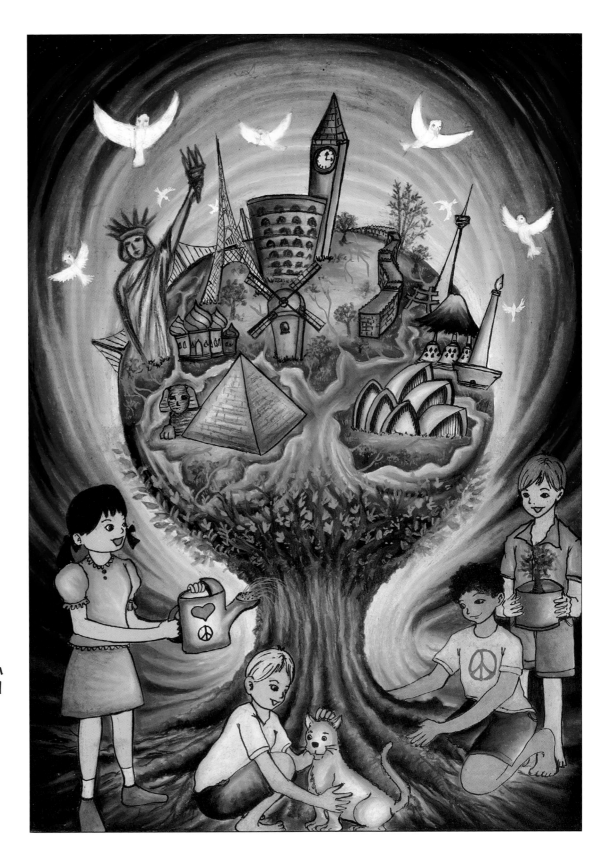

Let's Protect Our Earth
to Make a Better World
for Children
William Christian
Age 13
Indonesia
Kolese Kanisius Junior High
School, Jakarta
2003

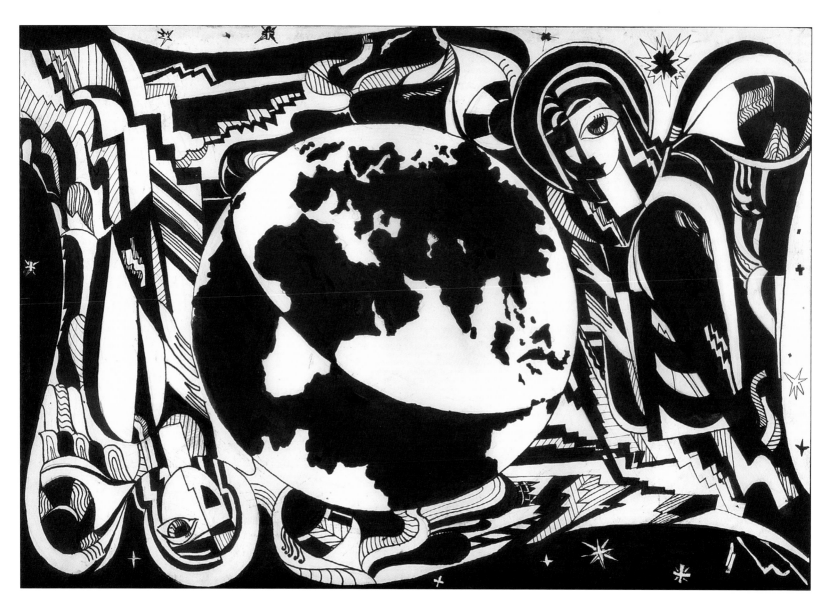

Our Planet
Solomia Kostyrka
Age 13
Ukraine
School No.30, Lviv
1997

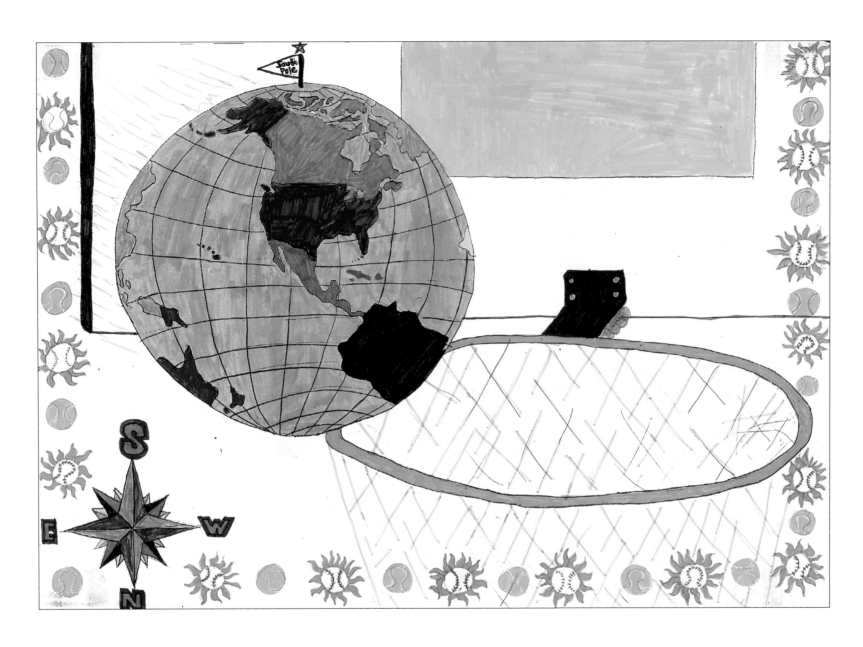

Untitled
Cale Marthens
Age 13
United States
Sussex School, Stevensville, Montana
1993

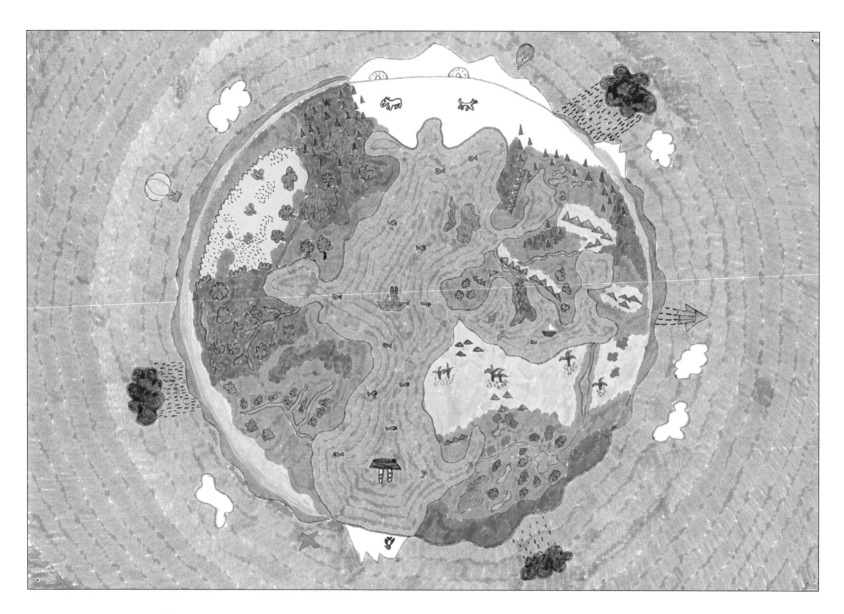

The Oceans and the Sea Is Our World
Malamatenia Voulgara
Age 13
Greece
Thessaloniki
1997

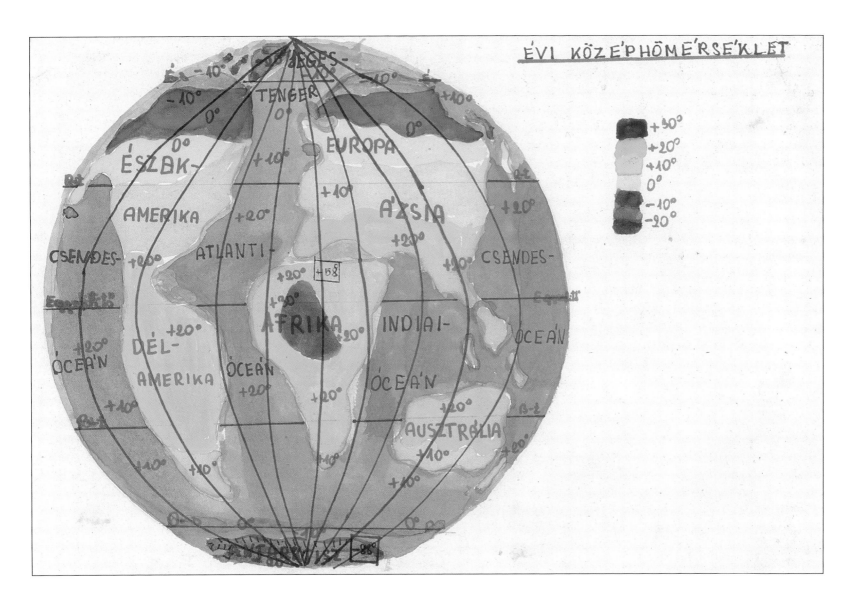

Climate of the Earth
Edina Király
Age 13
Hungary
Tunyogmatolcs Primary School, Kölcsey
1995

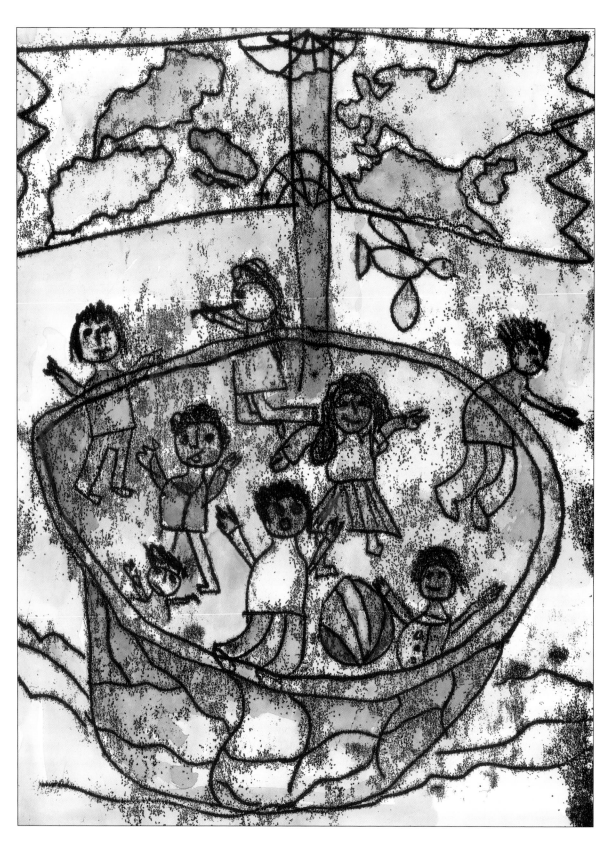

Around the World in
a Walnut Shell
Ladislav Ziga
Age 13
Slovak Republic
Detský domov pri OŠI Ždaňa,
Košice-okolie
1997

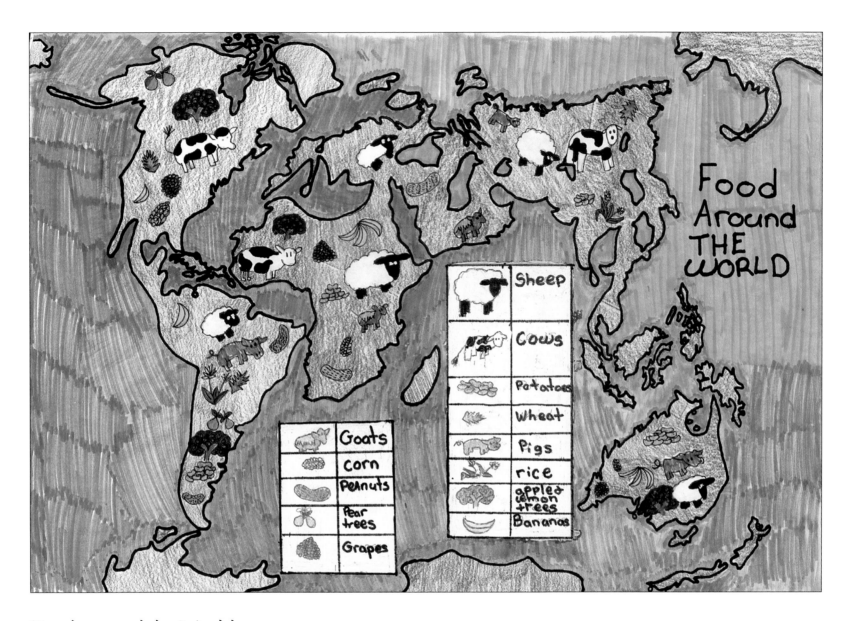

Food around the World
Stacey Van Natter
Age 13
Canada
Lynndale Heights, Simcoe, Ontario
1999

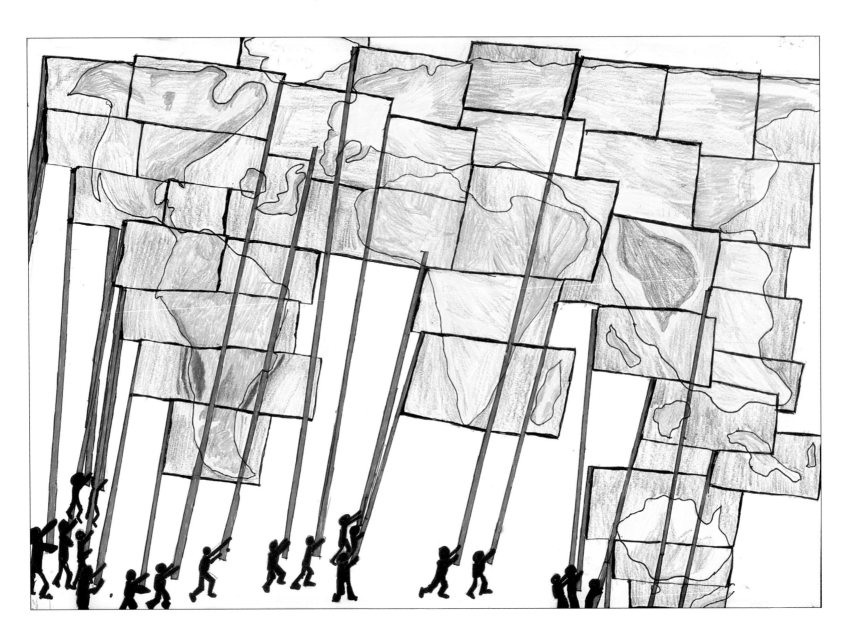

Untitled
Nathan Moscrop
Age 13
United Kingdom
Nunnykirk Centre for Dyslexia, Morpeth, Northumberland
2003

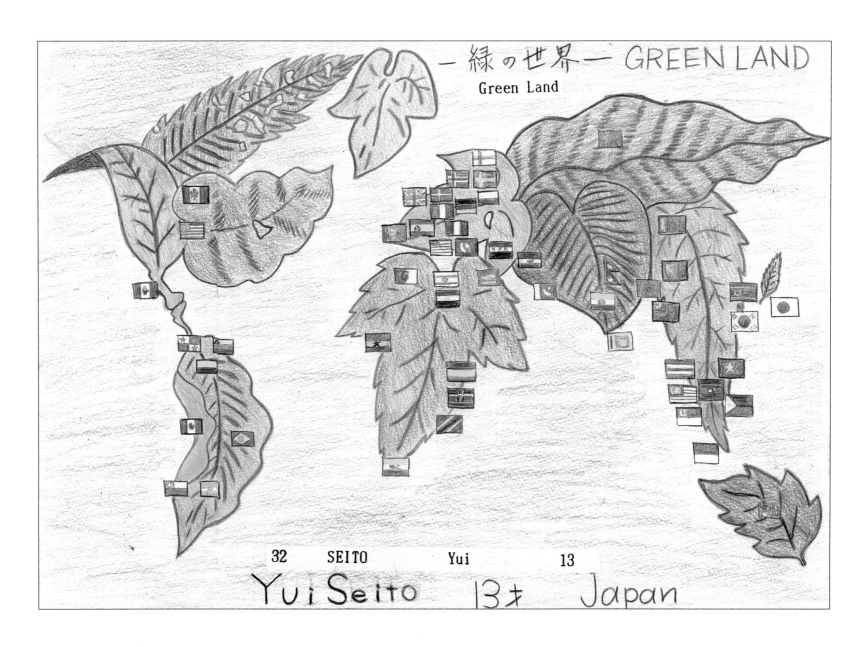

Green Land
Yui Seito
Age 13
Japan
1993

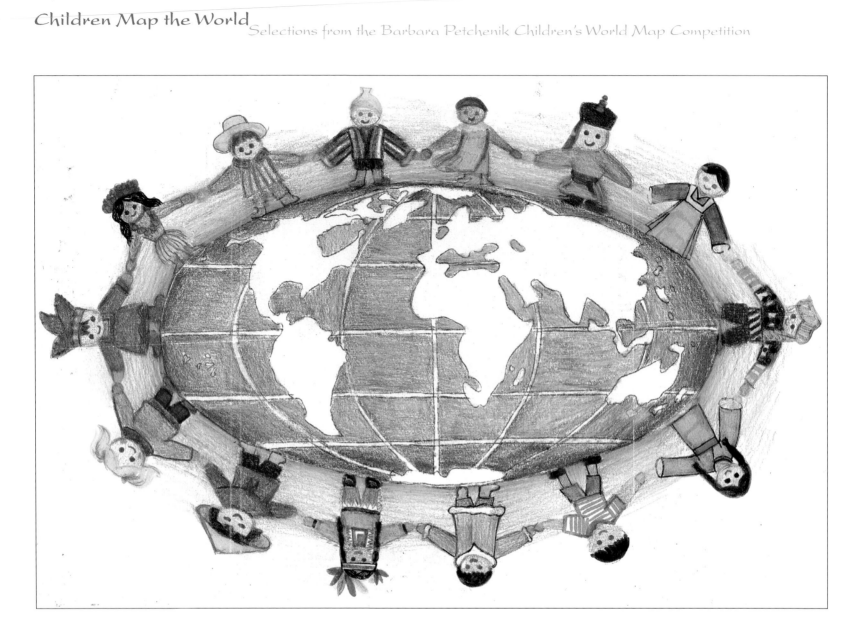

Children around the World
Jana Ďuranková
Age 13
Slovak Republic
ZŠ Žarnovica
1993

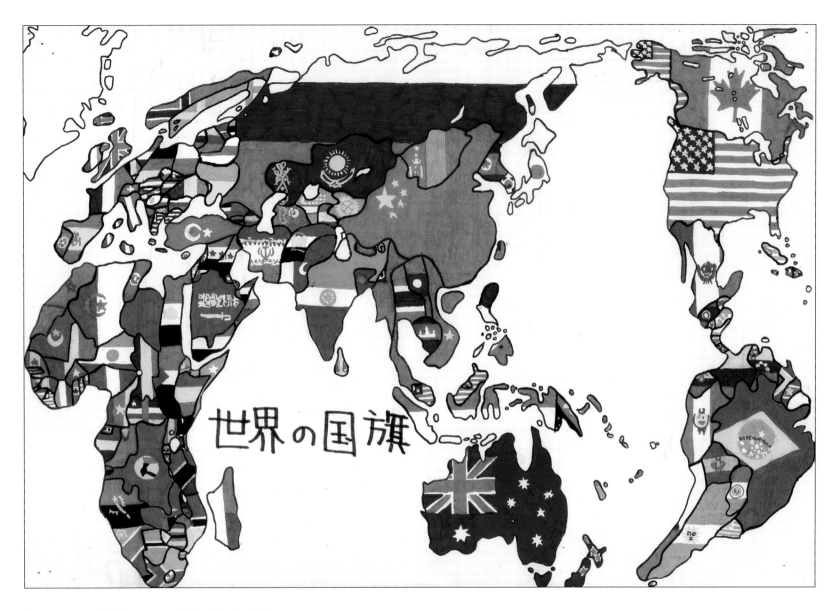

世界の国旗

National Flags of the World
Ikuko Hara
Age 13
Japan
Nishidai jh, Itabashi-ku, Tokyo
1999

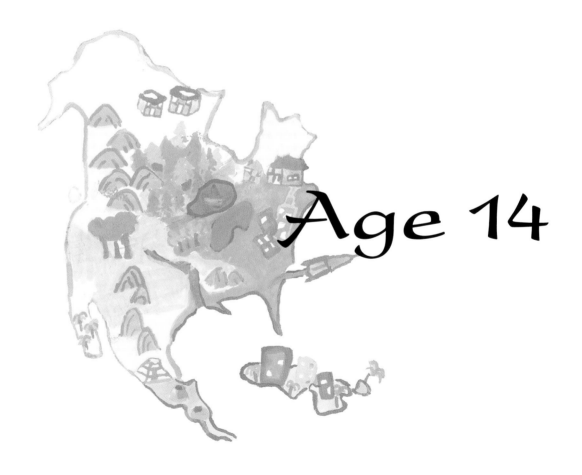

Age 14

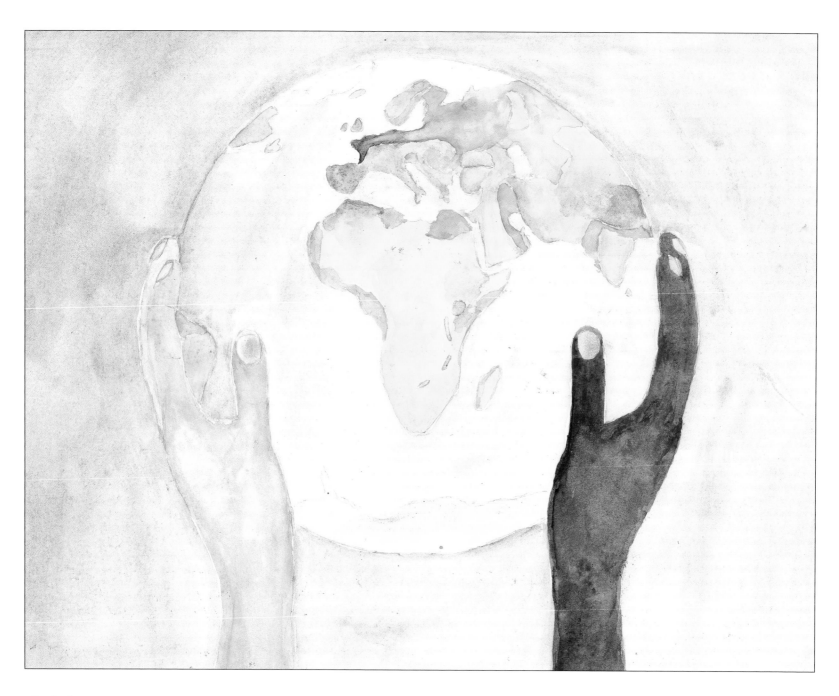

Solidarity
Julia Papp
Age 14
Hungary
Tunyogmatolcs Primary School, Kossuth Lajos
1995

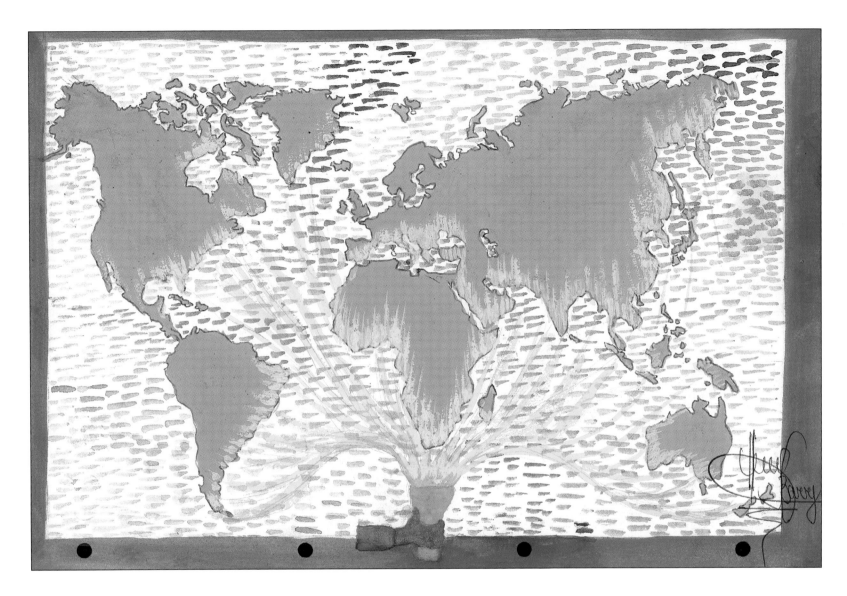

Torch of Liberty
Barry Thierno Hamidou
Age 14
Guinea
College Sainte Marie de Dixinn, Conakry
1999

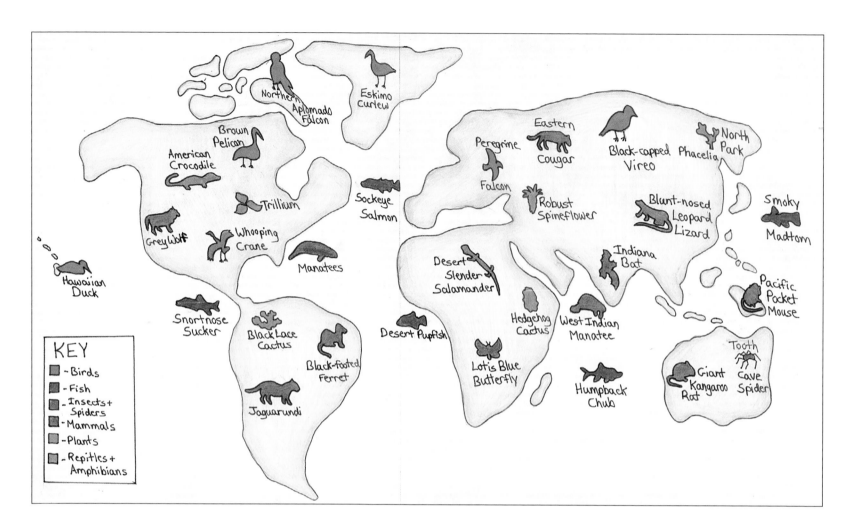

KEY
- ~ Birds
- - Fish
- - Insects + Spiders
- - Mammals
- - Plants
- - Reptiles + Amphibians

Our Endangered Species

Rachel Levine

Age 14

Canada

Thornhill Secondary School, Thornhill, Ontario

1995

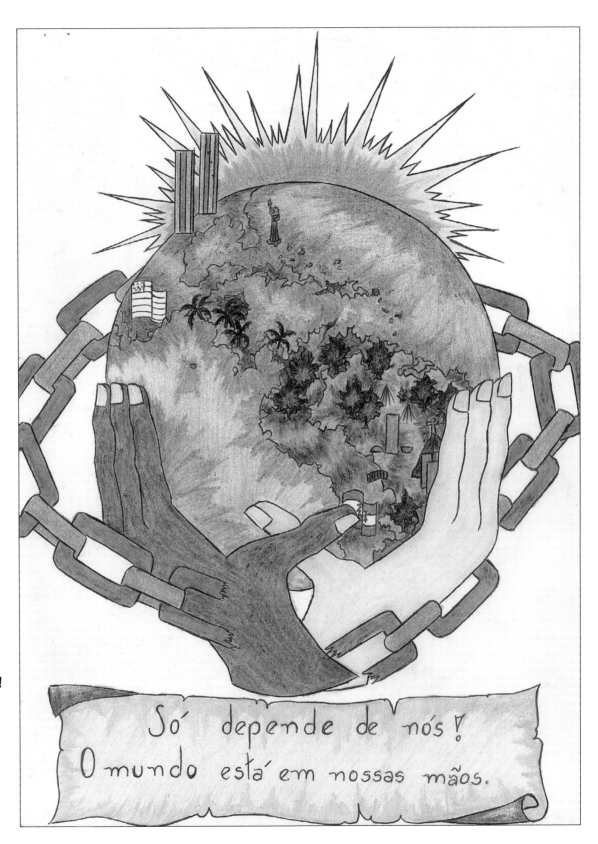

It Only Depends on Us!
The World Is in Our Hands
Tércio Silote
Age 14
Brazil
Interlagos
2003

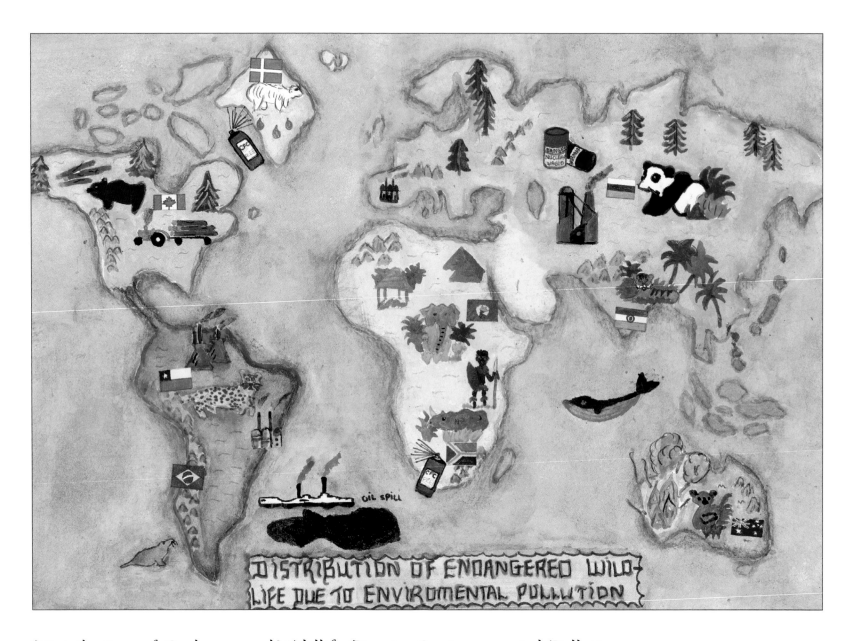

Distribution of Endangered Wildlife Due to Environmental Pollution
Candice Winterboer
Age 14
South Africa
Lyttelton Manor High School, Verwoerdburg
1995

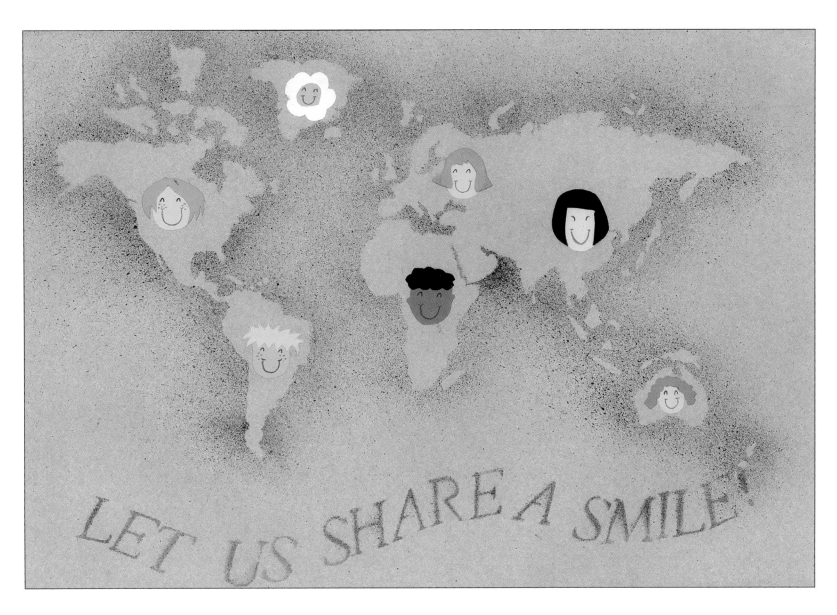

Let Us Share a Smile
Rashmi Hettige
Age 14
United States
St. Francis de Sales School, Philadelphia, Pennsylvania
1995

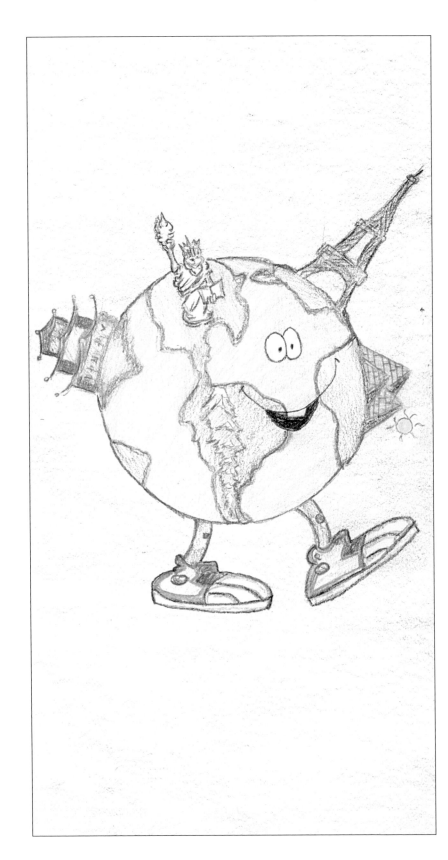

El Mundo y Sus Maravillas
Silvana Patricia Gutierrez Severino
Age 14
Chile
1993

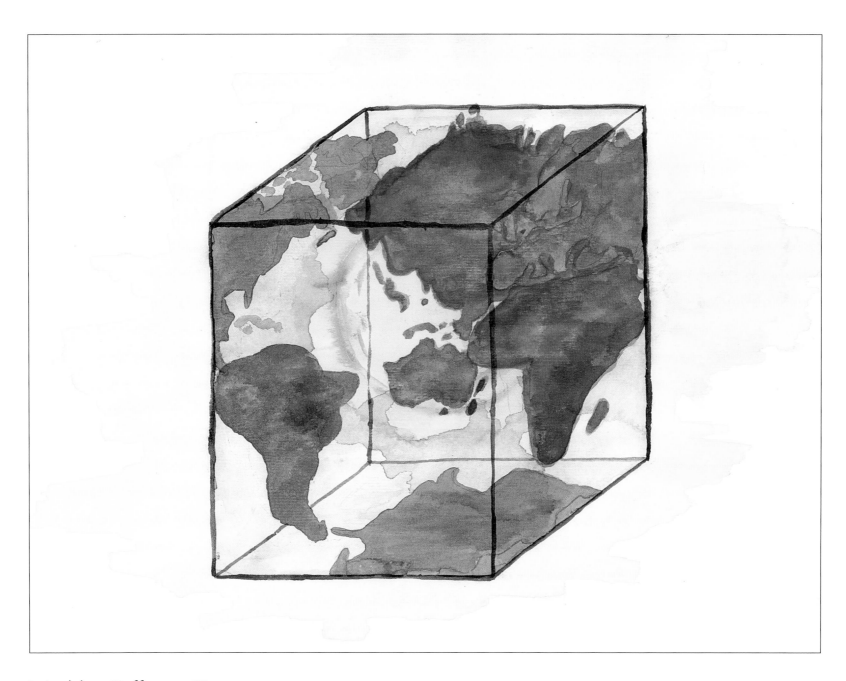

World in Different Forms
Vesna Bulešić
Age 14
Croatia
OŠ Bofoslav Šulek, Aleja Miroslava Krleže
1997

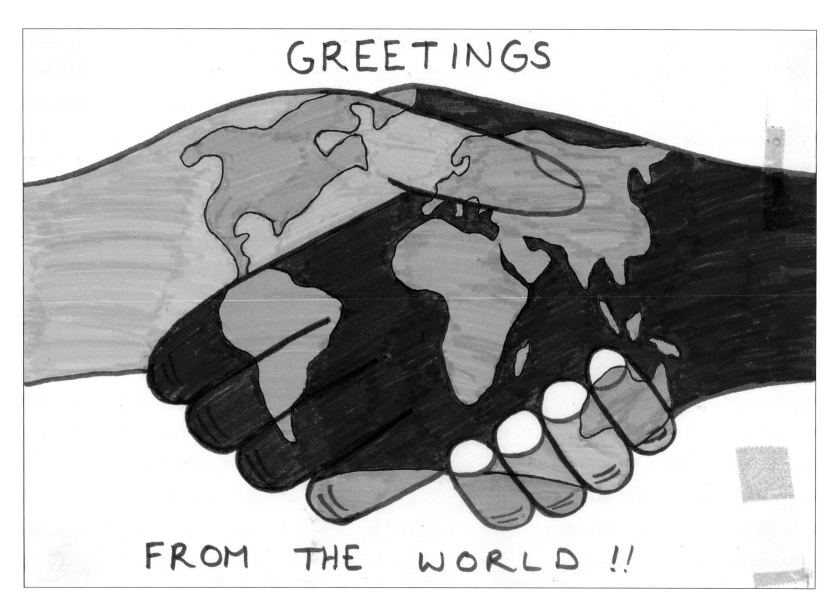

Greetings from the World
Henry Huang
Age 14
United Kingdom
Dulwich College, London
1993

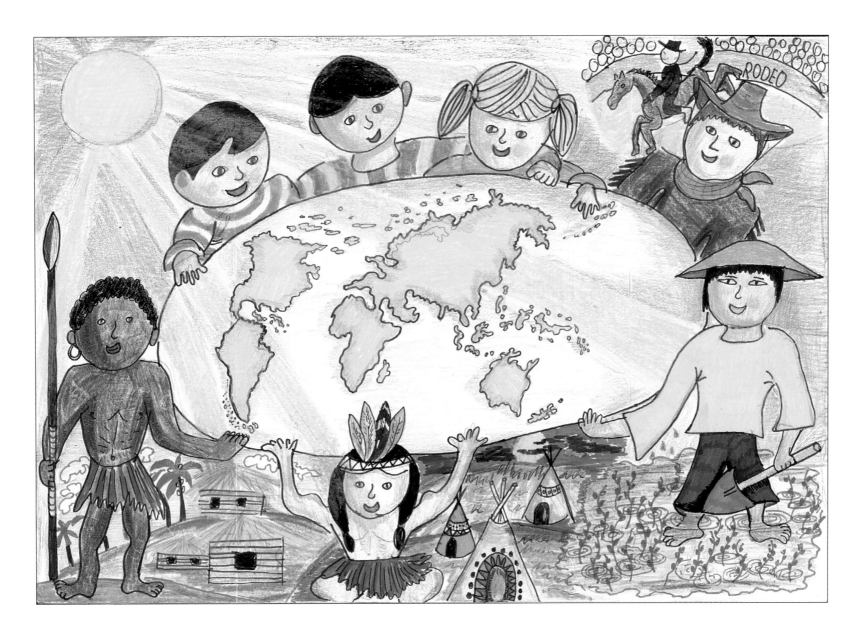

Protect Our World
Igor Dŭranka
Age 14
Slovak Republic
Zākladnā Škola, Žarnovica
1995

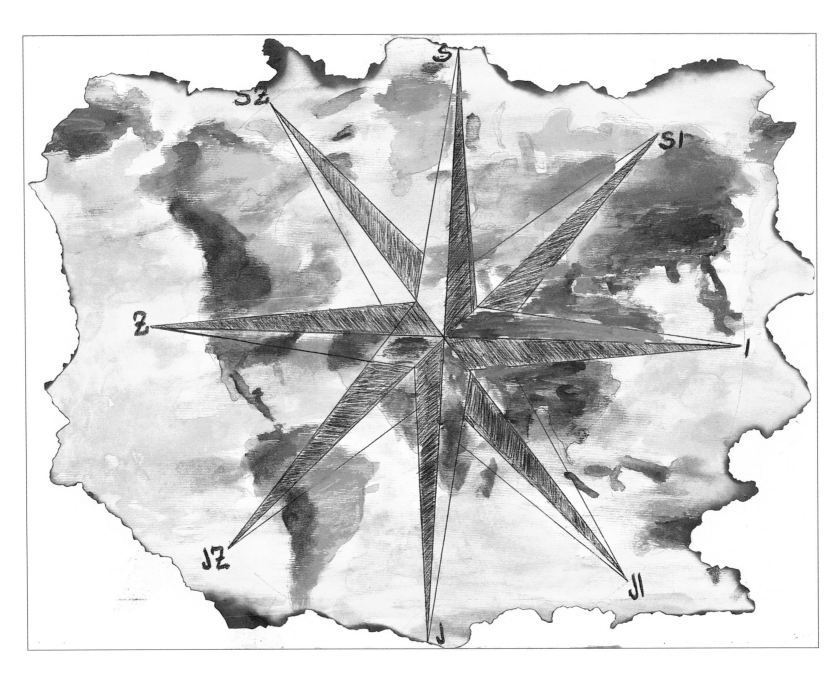

Compass Card
Anita Matkovic
Age 14
Croatia
OŠ Bofoslav Šulek, Aleja Miroslava Krleže
1997

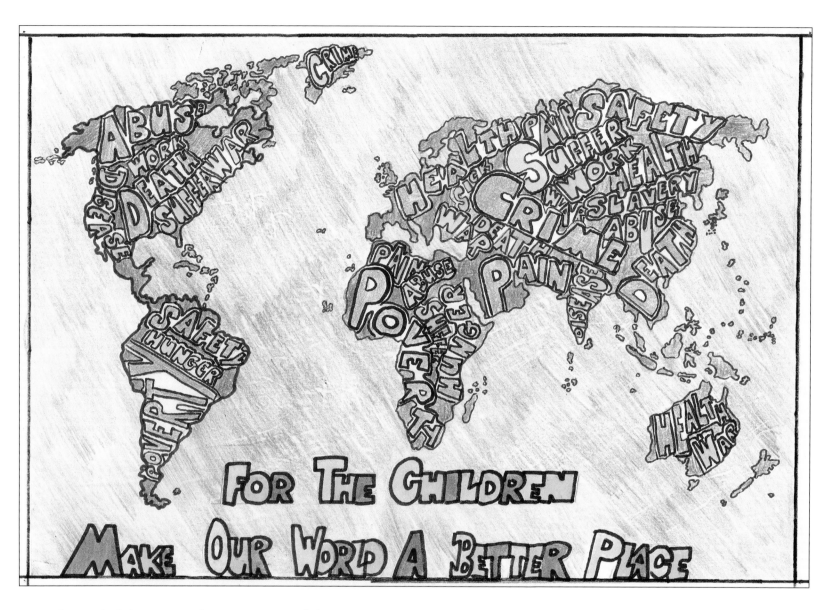

For the Children Make Our World a Better Place
Ben Hankins
Age 14
United Kingdom
Bradon Forest School, Purton, Swindon
2003

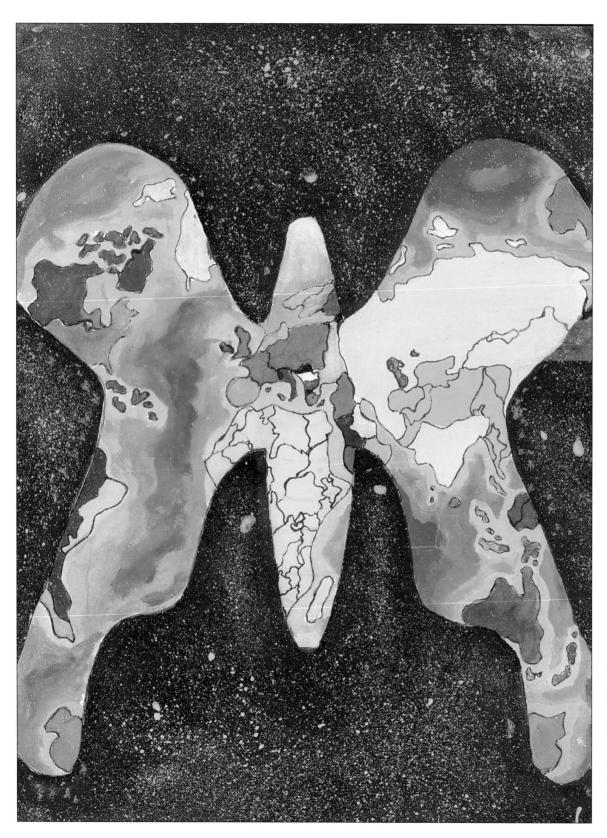

Making a Better
World for Children
Sonja Zaric
Age 14
Yugoslavia/Serbia and
Montenegro
Primary School 'Ratko
Mitrovic', Novi Beograd
2003

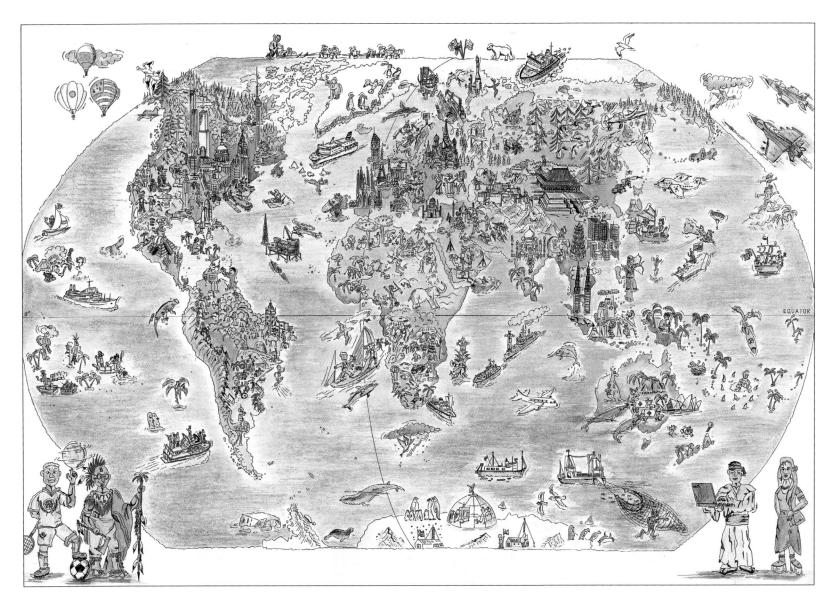

Economic Threats to Children's Lives
Atayan Samvel
Age 14
Belarus
Minsk
2003

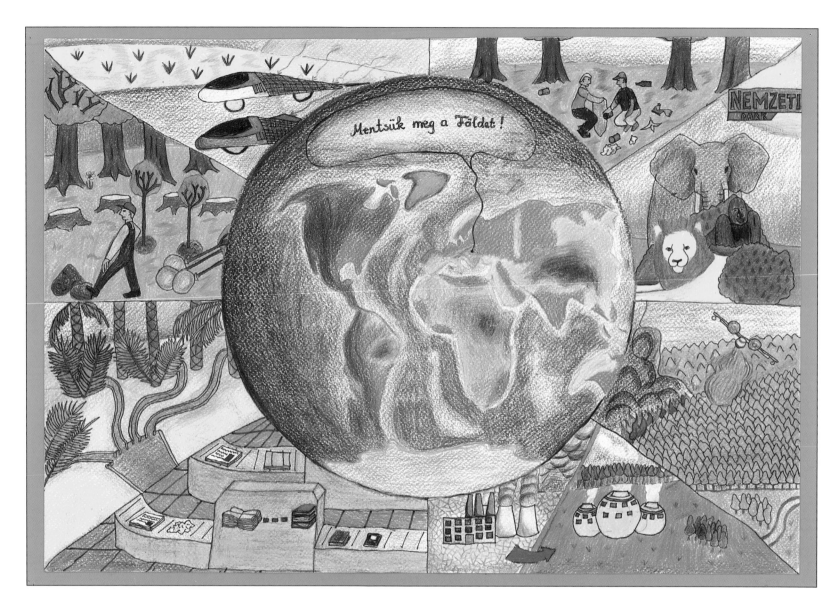

Save the Earth!
Gergö Koleszár
Age 14
Hungary
Art School of Szikszó, Rákóczi
2001

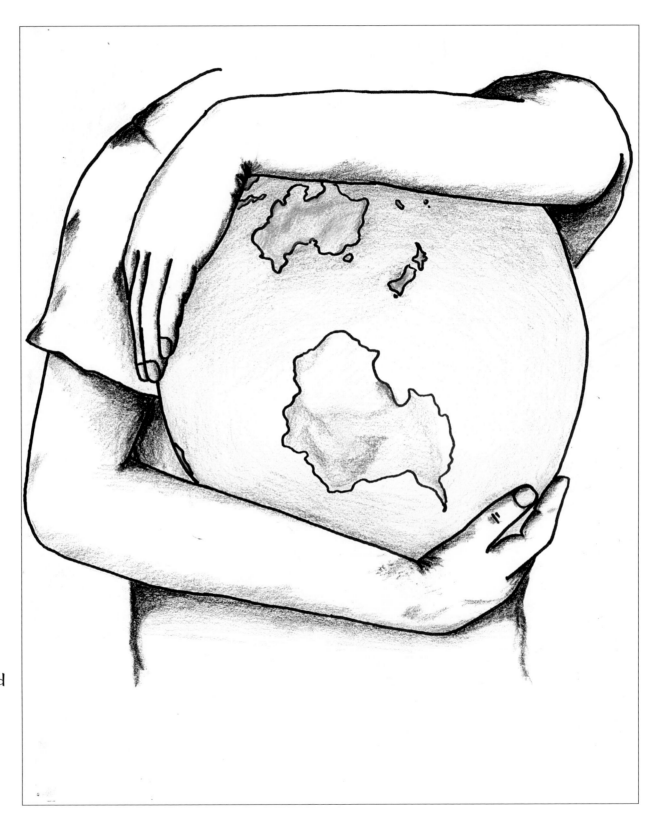

Mother and Child
Jessica Bunker
Age 14
New Zealand
Rotorua Girls High
School, Rotorua
2001

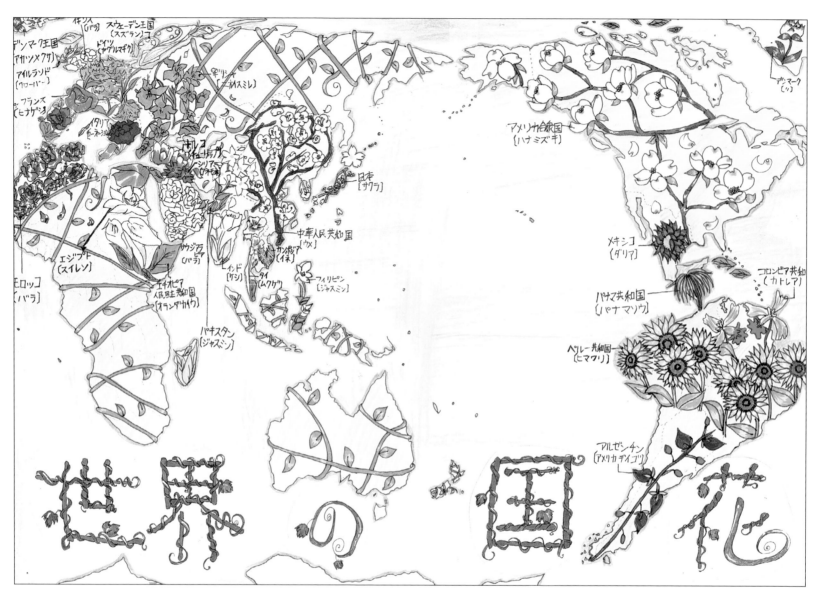

Let Flowers Bloom All over the World

Mika Hayashi and Nagisa Kawasaki

Age 14

Japan

Nishidai jh, Tokyo

1999

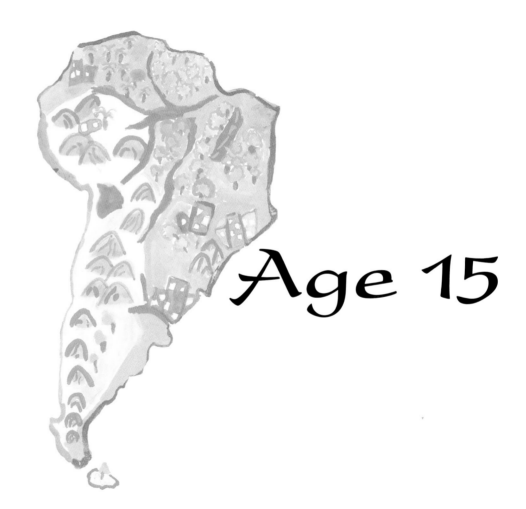

Age 15

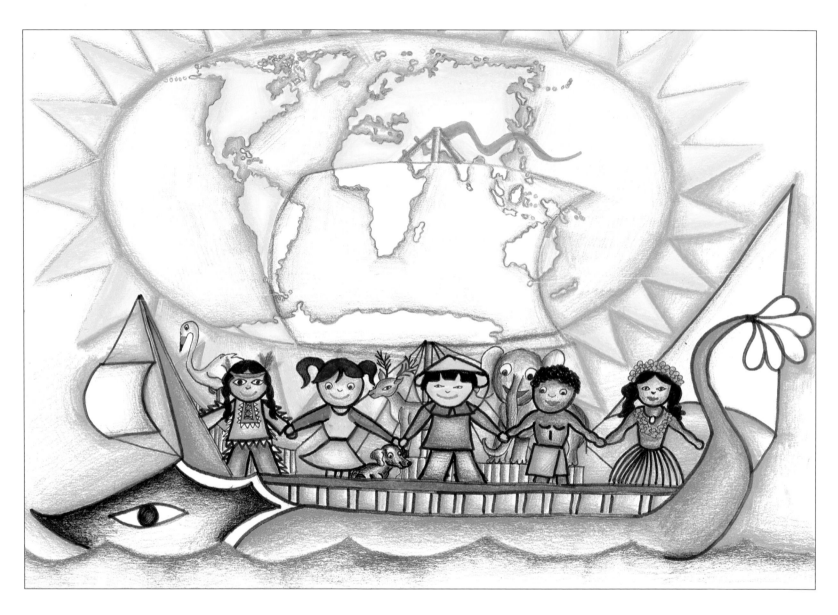

Wonderful World of a Child's Dream
Jana Ďuranková
Age 15
Slovak Republic
Gymnázium, Nová Bana
1995

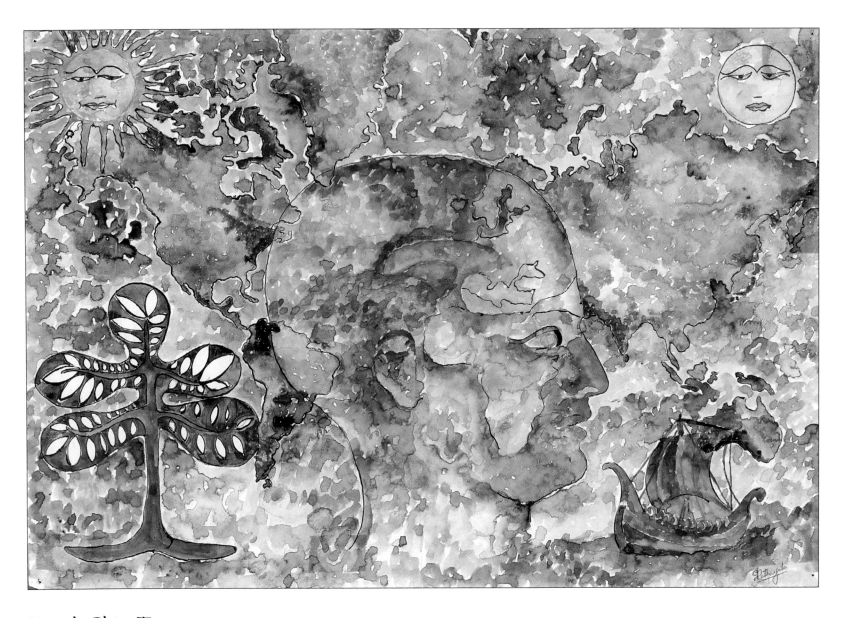

Head, Ship, Tree
R.M. Sisara Samanmali Ratnayake
Age 15
Sri Lanka
St. Anthony's Balika Maha Vidyalaya, Kandy
1993

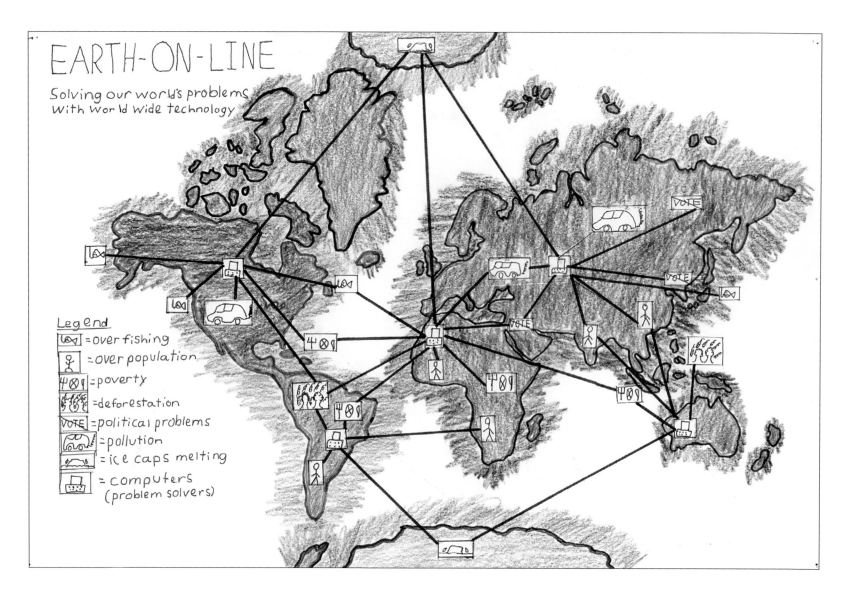

Earth-on-line
Mark Baxter
Age 15
Canada
Sir Winston Churchill Secondary School, Vancouver, British Columbia
1997

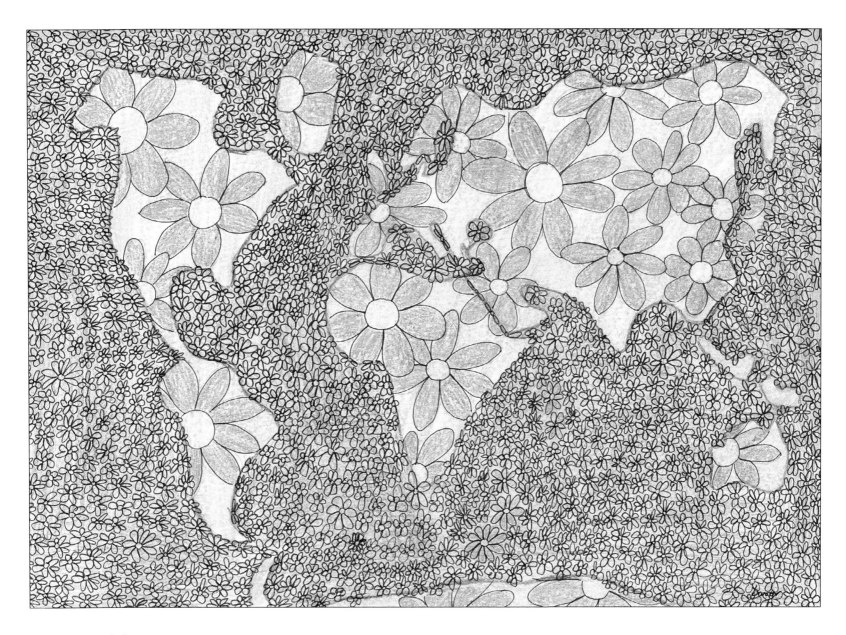

1001 World
Davor Crnogorac
Age 15
Croatia
X Gimnazija Klaićeva 7, Zagreb
1995

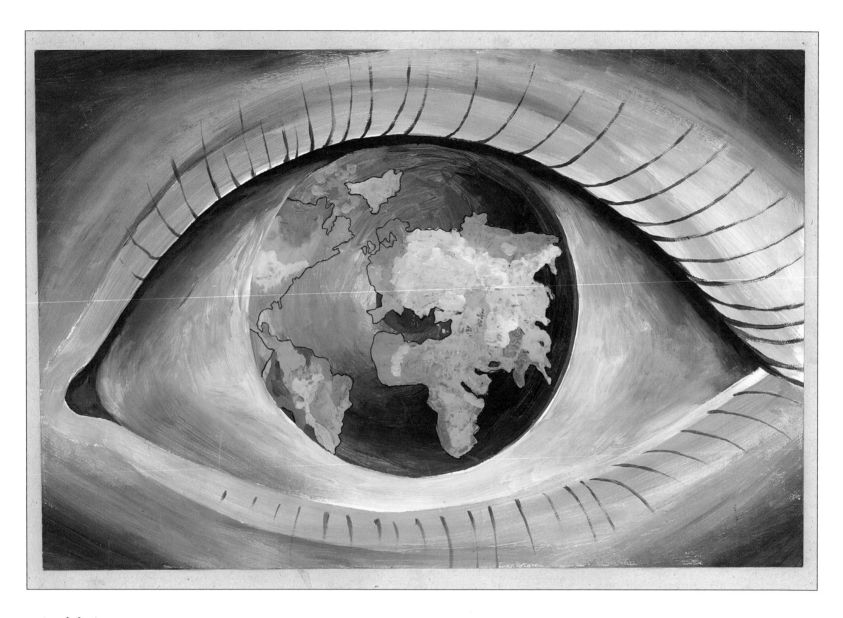

World View
Yasmin Dahan, Dasha Mitroshin
Age 15
Israel
Ayyelet HaShahar, Tiberias
2001

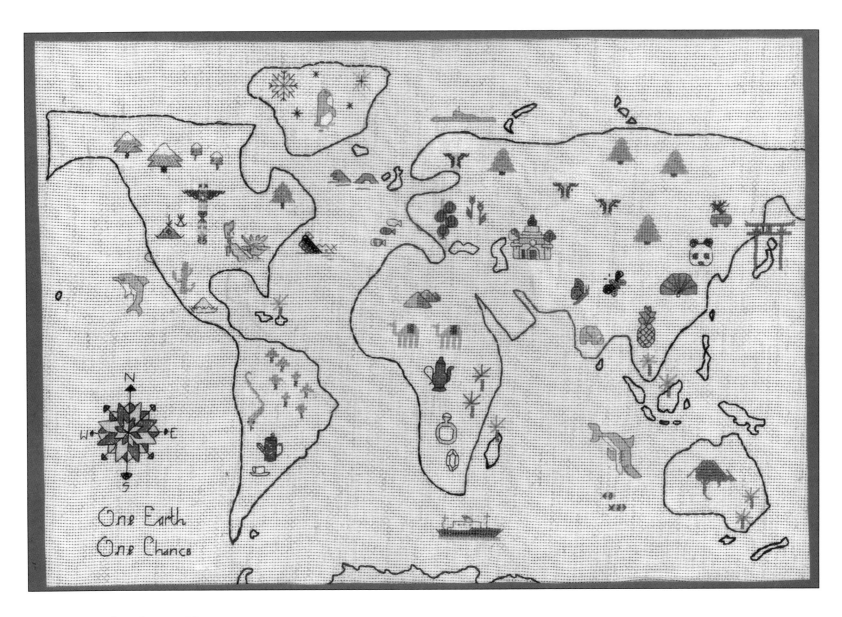

One Earth, One Chance
Carly Ann Murray
Age 15
United Kingdom
Cefn Saeson School, Cimla, Neath
2001

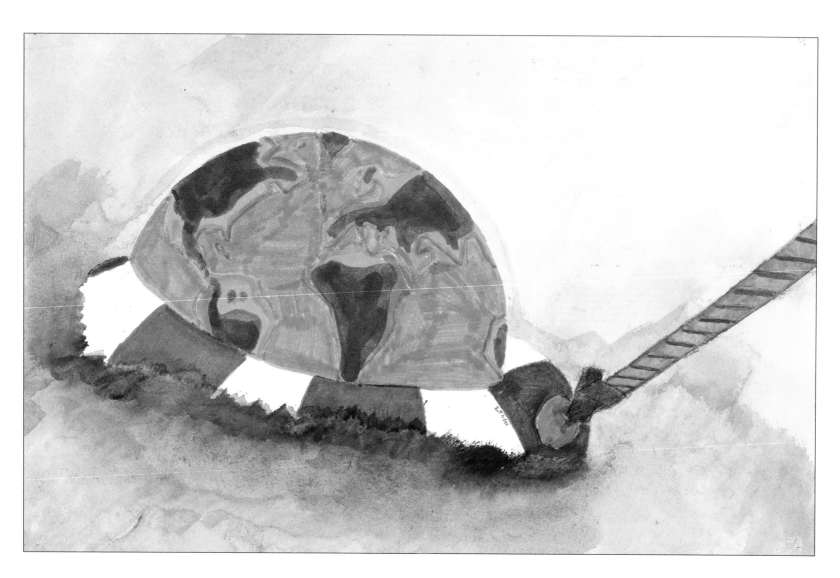

Untitled
Stelios Petrakis
Age 15
Greece
Thessaloniki
2001

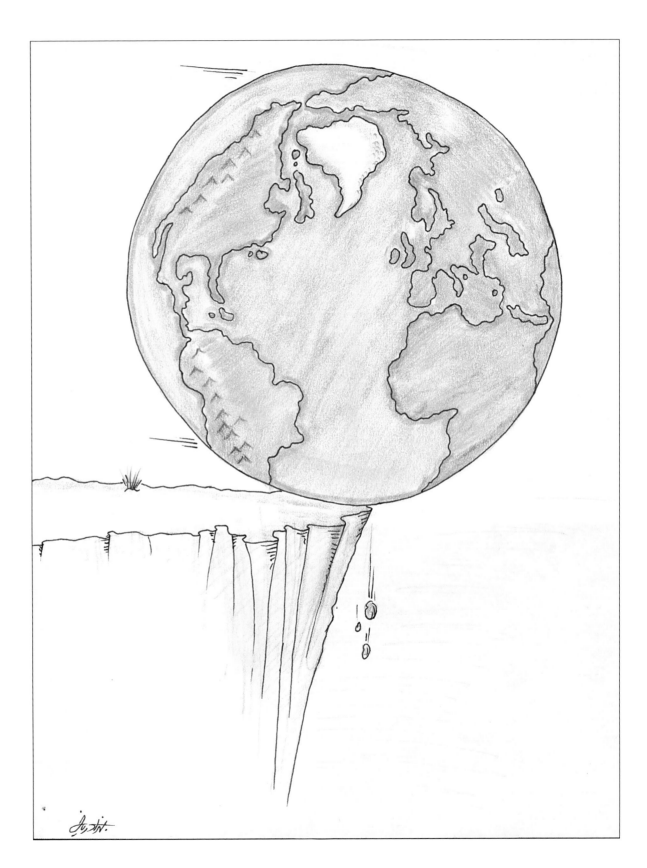

Save the Earth
Behzad Riazi
Age 15
Iran
Sh. Danesh High School,
Tehran
2001

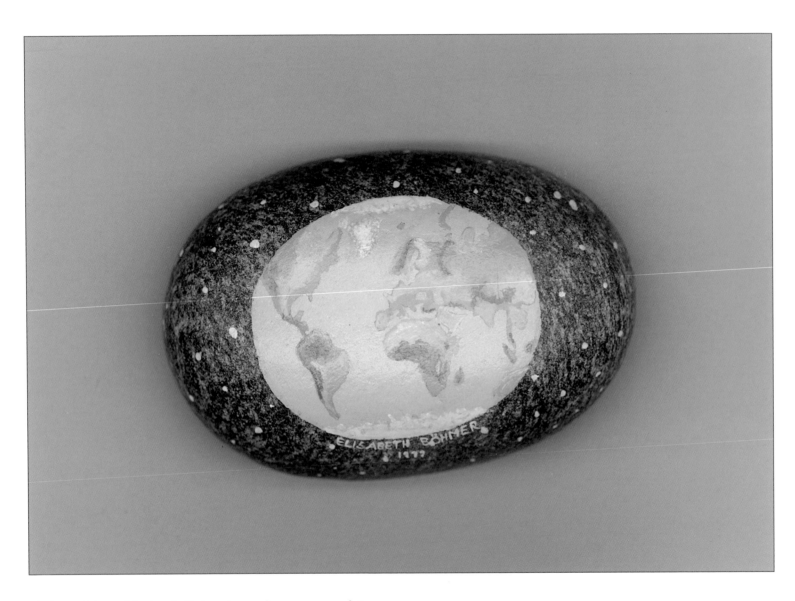

It's a Hard World! (painted on a rock)
Elizabeth Böhmer
Age 15
Sweden
Tattby skola, Saltsjobaden
1999

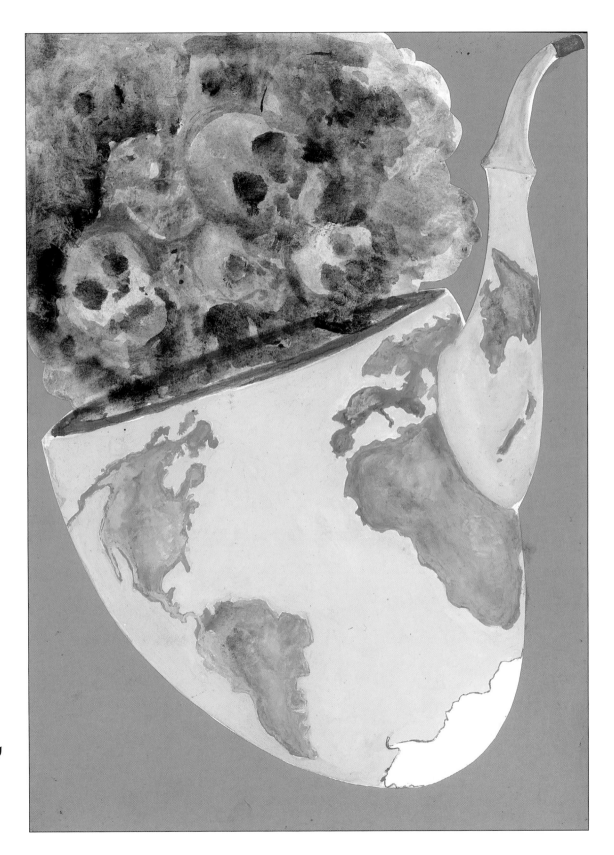

No Smoking
Horváth Ágnes
Age 15
Hungary
1993

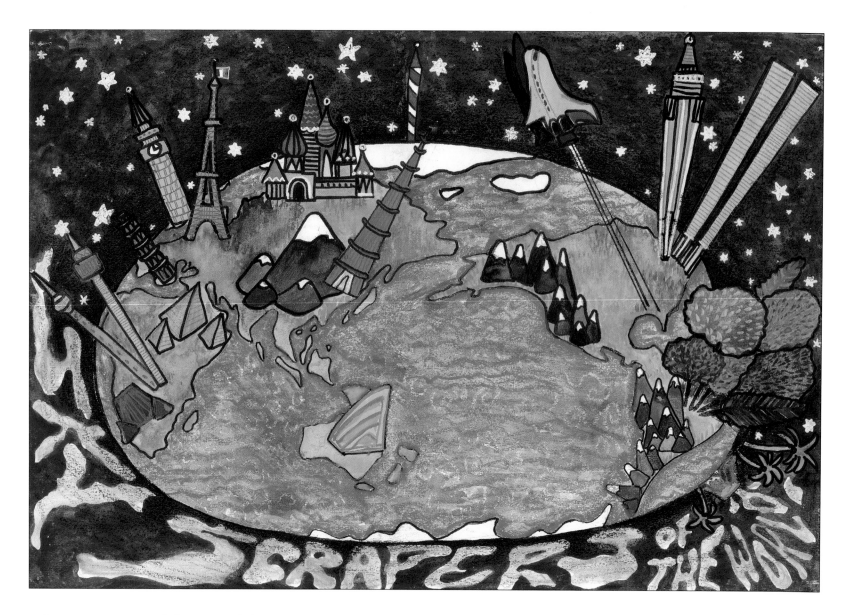

Skyscrapers of the World
Mia Müller
Age 15
South Africa
Menlo Park High School, Pretoria
1997

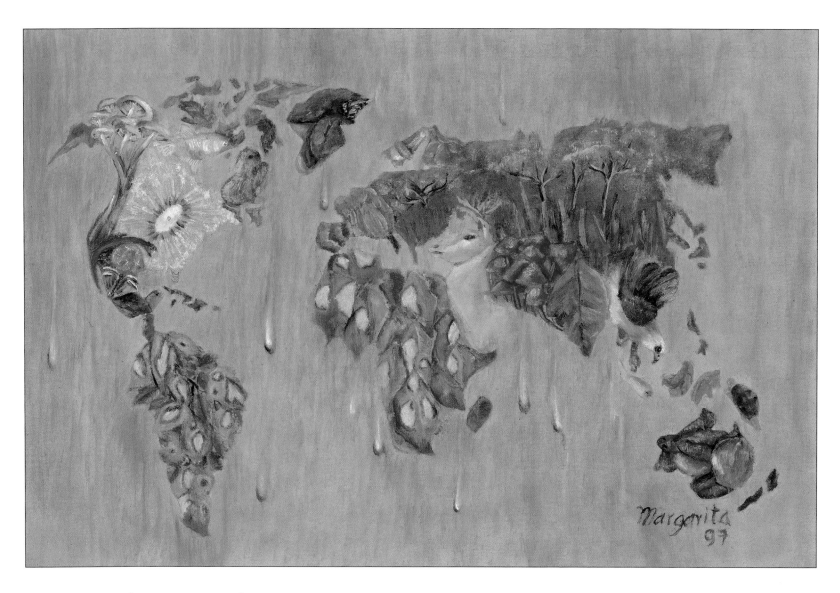

A Dream of a Happy Life
Margarita Ivette Villar M
Age 15
Aguascalientes, Ags, Mexico
1997

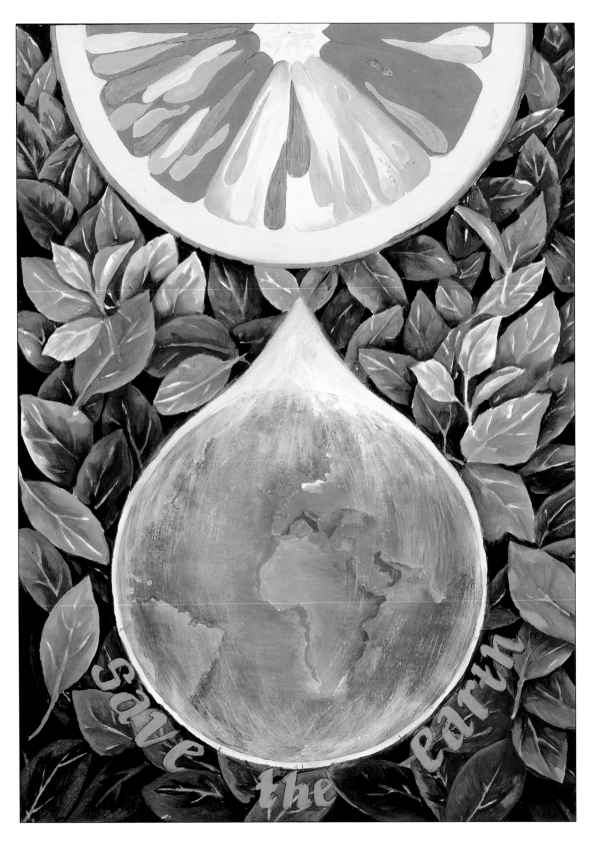

Save the Earth
Kirstin Brunette
Age 15
South Africa
Menlo Park High School, Pretoria
2001

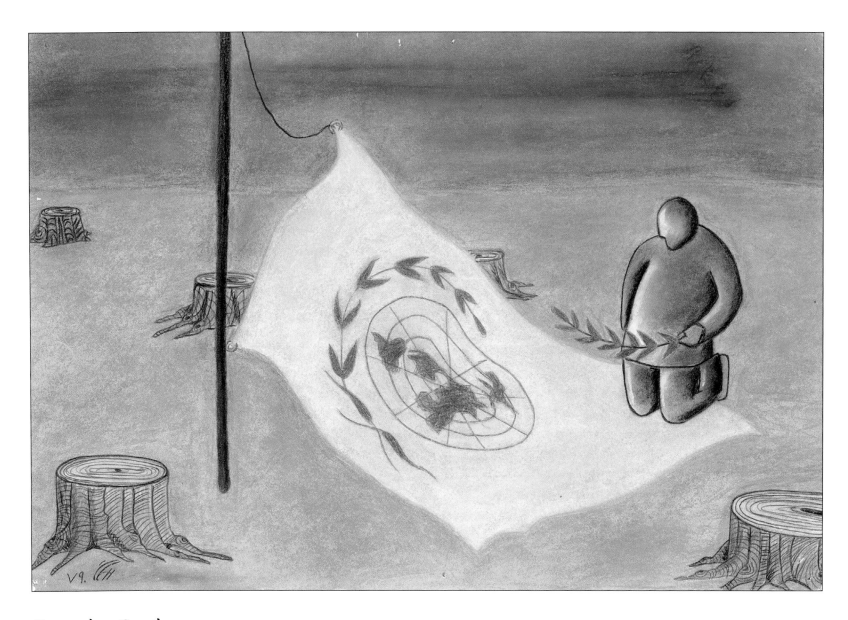

Save the Earth
Samane Khani
Age 15
Iran
Golestan Kabir High School, Tehran
2001

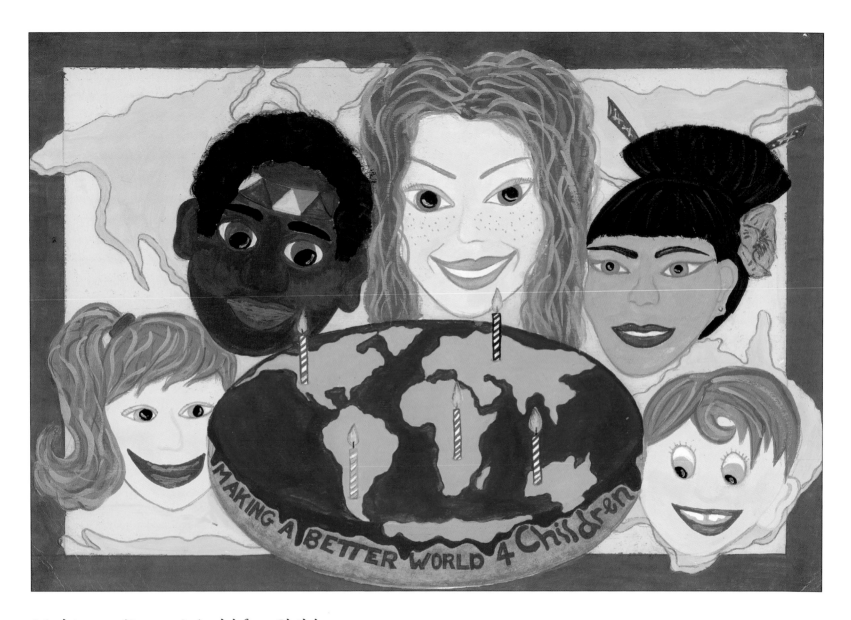

Making a Better World for Children
Ilse Wiehahn
Age 15
South Africa
Menlo Park High School, Pretoria
2003

A biographical note

Barbara Bartz Petchenik

Barbara Bartz Petchenik was one of the modern women pioneers in cartography and in the International Cartographic Association. Among her major interests were maps and atlases for children. From 1965 to 1987, she wrote numerous pieces about the topic, and it continued to be of considerable interest to her throughout her life. For this, the ICA named the Children's World Map Competition in her honor in 1993.

Barbara Bartz was born on August 17, 1939, in rural northern Wisconsin. Her family was well established and highly thought of in the community and, though not wealthy, were well off. She grew up in a secure and nurturing environment that gave her the necessary self-confidence for real achievement. By the time she was in high school, "the Bartz girls" (her seven cousins and herself—there were hardly any boys in the family) were recognized as achievers and leaders, both academically and socially. She notes that it was "more the former than the latter" in her case, as she "was not a prom queen".

She did not find much information about careers prior to attending college, but two books in her small-town high school library (Karl Menninger's *The Human Mind* and Ralph Lapp's *Atoms and people*) fascinated her, making her feel that she could be a psychiatrist or a nuclear physicist. She was not encouraged in either direction by her family, and her mother especially hoped that she would become a nurse.

Barbara obtained a B.S. in 1961 from the University of Wisconsin-Milwaukee with a major in chemistry and a minor in English. She spent a year working at U.W.-Milwaukee as an instructor in geography, and in September 1961 served as the founding "map librarian" of the New Map and Air Photo Library there. She entered the graduate program at U.W.-Madison in 1962 with a National Defense Education Act Fellowship in cartography, along with Joel Morrison and others. She originally intended to complete a PhD in physical geography, concentrating on soils, with the ultimate goal of teaching at the

university level. In some autobiographical notes she says that "a whole lot of things happened that changed my course," which were too complicated to tell; she felt that things just "happened" to her.

Barbara wanted to live in the Chicago area, and after she completed her master's degree in 1964, she became a cartographic editor with the Field Enterprises Education Corporation. This entailed designing, conducting, and analyzing the research needed to produce maps and other material for nine to fourteen year olds for the *World Book Encyclopedia*. She spent one year in San Francisco as a cartographic consultant for Field Enterprises, and after she finished her PhD in 1969, she returned to Chicago.

In 1970, Barbara moved to a five-year position at the Newberry Library as cartographic editor of the *Atlas of Early American History*, which she planned, designed, and produced in conjunction with the editor-in-chief Lester Cappon and the staff of historians. From 1975 until her death in 1992, she served as the senior sales representative of cartographic services for the R. R. Donnelly and Sons Company. In her writing, she continued to pursue her interest in education.

Barbara Bartz Petchenik wrote at least fourteen (or fifteen, if you count a letter) pieces about maps for children from 1970 to 1987. Others have made good use of her work over the years. One author credited Barbara with coining the phrase "map-like object" (MLO), which she used in "Facts or values . . ." (pp. 35–36) to describe poorly designed or ill-thought-out images that look like maps, but are so lacking in any potential spatial meaning that they do not deserve to be called maps. This opinion illustrates her firmness and matter-of-fact approach to such issues. She was very interested in atlases for children. She wrote several articles that delve into fundamental aspects of atlases for children by informally considering particular atlases. She thoughtfully observed

Maps are mostly far too complex to "learn" at one or even many glances. The only way to try to make sure that children leave school with some idea of the relative shapes and sizes and arrangements of labeled earth areas and features is to provide opportunities for them to see and use these images (maps) on a highly repetitive and (I happen to prefer) structure basis.[1]

She did much of her research about maps for children during her tenure with Field Enterprises. When she was faced with the challenging task of designing maps for the children's *World Book Encyclopedia*, she became the first cartographer to base maps for children on empirical evidence of what they could most easily understand and the types of maps they preferred. Barbara individually interviewed about one thousand elementary school children and invited them to interpret alternative styles of small-scale maps. From this work, she identified characteristic difficulties children had with the interpretation of scale, coordinates, symbology, and typography. Her research showed that children valued clarity in cartography and liked less-cluttered maps with more clear spaces. She noted that although teachers claimed map use was an important skill, children were rarely taught how maps worked. Above all, she recognized that children are a large and important group of map consumers, that they do not approach maps in the same way as adults, and that their distinct perspectives should be taken into account in the process of map design. The articles and research publications in the bibliography that follows provide opportunities to learn more about her philosophy on cartography, especially involving maps for children.

Barbara's personal life kept her in Chicago. In 1972, she married Kenneth H. Petchenik, whose publishing career and family concerns (three young sons by his previous marriage) made it essential to remain there. She delighted in having this ready-made family and recognized the problems encountered by young professional women facing decisions about child bearing.

Over the years, Barbara was active in professional organizations, such as the American Congress on Surveying and Mapping's American Cartographic Association, the Association of American Geographers, the Society of Automotive Engineers, and the International Cartographic Association. She served as a member of the editorial board of *The American Cartographer* and as a member of a number of other committees. Through her efforts, the long-running award for a map designed by a student was given through the ACSM Map Design Competition and sponsored by the Donnelley Company. She served as a member of the U.S. National Committee to the International Geographical Union (representing ACSM) and had a term as chair of the U.S. National Committee for the International Cartographic Association (ICA). She participated in other ICA activities over the years, and in 1991 at the General Assembly in Bournemouth, England, she was the first woman to be elected as a vice president of the ICA.

Over the nearly twenty years that I knew Barbara, I was always impressed by her intelligence and good humor. We had in common being taller than average. Along with Trish Caldwell, we became an informal group called TWIC—Tall Women in Cartography. We even had an auxiliary group called SMIRS—Short Men in Remote Sensing. This was a source of amusement for us all. We enjoyed a lively camaraderie over the years. Her presence, scholarly contributions, and spirited intellectual discussions have been and will be missed. The Children's Map Competition is one way of keeping her alive in our memories. The maps in the volume are just a small sample of the wonderful contributions since 1993 from children all over the world.

Alberta Auringer Wood (with assistance from Patrick Wiegand)
February 14, 2005

1 Fundamental considerations about atlases for children. 1987. *Cartographica* (24):16–23.

Works by Barbara Bartz Petchenik about children and maps

Cartography for children: A research approach. 1971. *La revue de geographie de Montreal* 25: 407–410.

Designing maps for children. 1971. *Cartographica* monograph 2: 35–40. Presented at the symposium on the Influence of the Map User on Map Design at Queen's University.

Evaluation of two-color political maps in World Book (Chad, Singapore, Sierra Leone, Formosa, Nigeria). 1967. Research report for Field Enterprises Educational Corporation, Chicago, 43.

Experimental use of the search task in an analysis of type legibility in cartography. 1970. *Journal of Typographic Research* 4 (Spring): 102–108. Reprinted in *The Cartographic Journal* 7 (2): 103–112.

Facts or values: Methodological issues in research for educational mapping. 1984. Paper presented at the Twelfth Conference of the International Cartographic Association, Perth, Australia, August 6–13. *Technical Papers* 1: 788–804. Reprinted as essay 2 in Value and values in cartography *Cartographica* 22 (3): 20–42.

Fundamental considerations about atlases for children. 1987. *Cartographica* monograph 36, 24 (1): 16–23.

Map design for children. 1965. Research report for Field Enterprises Educational Corporation, Chicago, 224.

Map type: Form and function. 1966. Research report for Field Enterprises Educational Corporation, Chicago, 145.

Maps and children. 1971. Letter in *Journal of Geography* 71 (2): 68.

Maps in the classroom. 1970. *Journal of Geography* 69 (January): 18–24. Reprinted in *Social science and geographic education: A reader*. 1971. John M. Ball, John E. Steinbrink, Joseph P. Stoltman, eds. New York: John Wiley and Sons, Inc.

Nature of research in education. 1972. *Journal of Geography* 71 (4): 215–232.

Review of *Junior atlas of Alberta* by J. C. Muller and L. J. Wonders. 1981. *The American Cartographer* 8 (1): 83–85.

Review of *Junior atlas of Alberta teachers manual* by W. C. Wonders. 1981. *The American Cartographer* 8 (1): 83–85.

Search: An approach to cartographic type legibility. 1969. *Journal of Typographic Research* 3 (4): 387–397.

Type variation and the problem of cartographic type legibility. Part one: Cartographic typography as a medium for communication; the cartographic view of legibility. 1969. *Journal of Typographic Research* 3 (2): 127–144.

What about Illinois? Or, children and a reference map. 1967. Research report for Field Enterprises Educational Corporation, Chicago, 71.

Works about Barbara Bartz Petchenik

Krejcie, Valerie Wulf. 1990. Barbara Petchenik. *Progress and Perspectives: Affirmative Action in Surveying and Mapping* (September–October 1990): 3.

Krejcie, Valerie Wulf, Leona Sorenson, Richard E. Dahlberg, and Joel L. Morrison. 1992. Barbara Bartz Petchenik: An appreciation. *ACSM Bulletin* 139 (September–October 1992): 24.

Morrison, Joel L. 1992. Barbara Bartz Petchenik: In remembrance. *Cartographica* 29 (2): 60.

Rundstrom, Robert A. 1992. Barbara Bartz Petchenik: A personal appreciation. *Cartographica* 29 (2): 60–61.

Taylor, D. R. Fraser. 1992. Barbara Bartz Petchenik: In remembrance. *ICA Newsletter* no. 2: 7. Reprinted in *The Cartographic Journal* 29 (2): 160.

Robinson, Arthur H. 1994. B. B. Petchenik (1939–1992). *Imago Mundi* 46: 174–175.

Web sites

For more information about submitting drawings to the competition, go to *www.icaci.org*

To see more past competition entries, go to *collections.ic.gc.ca/children*

For more information about International Cartographic Association Commission for Cartography and Children, go to *lazarus.elte.hu/ccc/ccc.htm*

Books from *ESRI Press*

When ordering, please mention book title and ISBN (number that follows each title).